FROM CONCEPT TO FORM

FROM CONCEPT TO FORM
In Landscape Design

Grant W. Reid
ASLA

JOHN WILEY & SONS, INC.

New York Chichester Weinheim Brisbane Singapore Toronto

This text is printed on acid-free paper. ∞

Copyright © 1993 by John Wiley & Sons, Inc. All rights reserved.

Published simultaneously in Canada.

This publication is designed to provide accurate and authoritative information in regard to the subject matter covered. It is sold with the understanding that the publisher is not engaged in rendering legal, accounting, or other professional services. If legal advice or other expert assistance is required, the services of a competent professional person should be sought.

16 15 14 13 12 11 10 9

Library of Congress Cataloging-in-Publication Data

Reid, Grant W.
 From concept to form in landscape design / Grant W. Reid.
 p. cm.
 Includes index.
 ISBN 0-471-28509-9
 1. Landscape design. I. Title.
SB472.45.R44 1993
712'.2—dc20
 92-22661
 CIP

To my father and mother,
Winston and Daphne Reid
who had the will to support their
son's education and the wisdom to
allow him to follow his own dreams.

Contents

Preface *ix*

1. **The Concept** *1*
 General Philosophical Concepts *1*
 Specific Functional Concepts *5*

2. **Form Development** *12*
 Basic Elements of Design *12*
 Geometric Form *15*
 1. The 90° Rectangular Theme *15*
 2. Angular Themes *18*
 3. Circular Themes *27*
 Naturalistic Form *45*
 1. The Meander *48*
 2. The Free Ellipse and Scallops *56*
 3. The Free Spiral *61*
 4. The Irregular Polygon *65*
 5. The Organic Edge *70*
 6. Clustering and Fragmentation *74*
 Integration of Form *78*

3. **Principles of Organization** *82*
 Unity *82*
 Harmony *84*
 Interest *86*
 Simplicity *88*
 Emphasis—dominance *88*
 Balance *91*
 Scale and proportion *93*
 Sequence *94*

4. **Case Studies** *95*
 Project 1 *96*
 Project 2 *103*
 Project 3 *108*
 Project 4 *115*
 Project 5 *122*
 Project 6 *127*

5. **Beyond the Rules: Anomalous and Provocative Design** *134*
 Acute Angle Forms *135*
 Counter Forms *137*
 Deconstruction *139*
 Social and Political Landscapes *142*
 Eccentric Landscapes *143*
 Landscapes of Distortion and Illusion *145*

Appendix: Guide Patterns and Geometric Construction Methods *149*

Index *161*

PREFACE

Whether you are a beginning designer or a seasoned professional, there is always room for improvement, change, or a fresh approach. Form in the landscape is the ultimate visual expression of the many forces that influence the design of outdoor environments. The site itself expresses opportunities and constraints, the owner or developer has specific needs and limitations, and the potential users demand ease and beauty. Landscape architecture embodies a skillful integration of these forces so that the changes on the land respond to human needs yet remain sensitive to the environment. The process of reaching an appropriate form is the focus of this book.

Form and function are critical elements of this process. Some believe that form follows function, that form is a logical outgrowth of an initial resolution of functional issues. Others feel that form has its own integrity and can influence how a site is utilized. In other words, form may precede or dictate function. Since concepts usually deal with ideas and functional problems, the title of this book may suggest a preference for the form-follows-function process. The author, however, believes that form is an integral part of function and that influences can flow in both directions.

Offered here is an approach to the design of landscapes, an approach that is for the most part logical and structured. Geometry and naturalism combine as the basis of this structure and become a way of thinking about form. This approach encourages you to engage in geometric and natural thinking, to go beyond the visual examples shown here, and to develop creative form that evolves from your own unique experiences. You are invited to use this book as a vehicle for new ideas, a prybar that can get you out of the box. Design blockages can be frustrating. Overcoming them and trying something new can be very exciting.

CREDITS

The following models and illustrations were done by Colorado State University Students: Figure 2-27, Robert Hill; Figure 2-34, Rustin Luken; Figure 2-46, Gina Belmont; Figure 2-51, Rick Kaldrovics; Figure 2-85, Monique McClusky; Figure 2-86, Mike Ransom; Figure 2-113, Connie Gunter; Figure 2-142, Jill Burson; and Figure 2-169, Mary Skaggs.

Photographs

Figures 2-21, 2-100, 2-223, 2-224 and 2-265 were done by EDAW, Inc. Figures 2-90, 2-156, 2-243, 2-252, and 3-11 were done by Daniel Nies. All other photographs and illustrations are by Grant W. Reid.

FROM CONCEPT TO FORM

The traditional approach to landscape architectural design usually begins with research, which investigates the goals of the client, the parameters of the site, and the needs of potential users. Documentation of this phase is expressed in the form of a *written program*, a *site inventory*, and/or a *site analysis*. Next in the design process is the *landscape concept*, which embodies a series of ideas about how to improve a specific site. Usually these ideas are a logical outcome of the research, but sometimes they precede the research and are later refined or modified by it.

Conceptualization can take many forms, but for our purposes it is useful to make a distinction between two realms of thinking. In one we are working with *general philosophical concepts*, in the other with *specific functional concepts*.

GENERAL PHILOSOPHICAL CONCEPTS

Philosophical concepts will unify to express the image, essential character, purpose, and underlying essence of the project. This level of conceptualization brings a sense of place to the site, the feeling that a particular site has a special significance, a special meaning beyond beauty and function. For a designer this level should force you to ask yourself "What is this place really all about?" Designs that are rooted in a strong philosophical base will have a strong sense of identity. A person experiencing such a space knows he or she is somewhere special. Too many of our professionally designed landscapes lack what the Greeks called "genius loci," the particular spirit of a site. The designer needs to discover and define this spirit to find out what the site wants to be, sensitively to interpret it into proposed uses and design form, and thereby to release its spirit and enhance the sense of genius loci.

To develop these areas a designer should be empathetic. It is necessary to identify with and understand the clients' or users' situations, feelings, and motives. What are the ideals, beliefs, or values that they may associate with the project and that can be translated into a physical form to become a true reflection of a cultural or personal context?

Halprin's fountain at the Embarcadero Plaza in San Francisco, California contains a cluster of bent and broken rectangular forms. Symbolizing the chaos and broken urban fabric that might follow a severe earthquake, they serve as a reminder that the city lies on an active fault line.

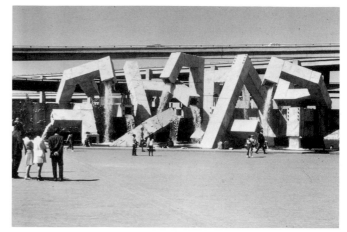

1-1.

A xeriscape demonstration garden designed by the author contains a looped walk symbolizing nature's continuing cycles of life and death. Its close integration with the scalloped stone wall represents the interdependence of different organisms in a natural ecosystem.

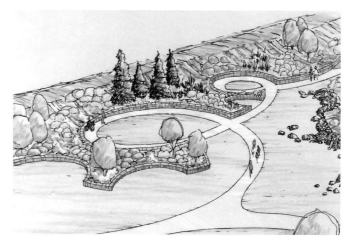

1-2.

The symbolism of this small garden was based on the owner's pending marriage and the joining of two families in a new house and property. A four-pointed star-shaped garden represented the harmonious blending of four people into one new entity with the solid rock grouping in the middle symbolizing the central unified heart of the family.

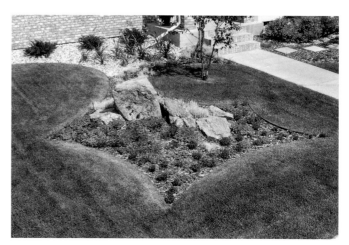

1-3.

Symbolic forms bring a unique dimension to space since they often add mystique and can be interpreted differently by each user. Traditional Japanese gardens are rich with symbolism yet open to a variety of interpretations. Rocks in sand may suggest ships on the ocean to one observer, people floating through clouds to another.

In general, western garden design lacks philosophical depth or symbolism. But it need not. There are many opportunities if designers will search for the spirit of the place and probe for meaning.

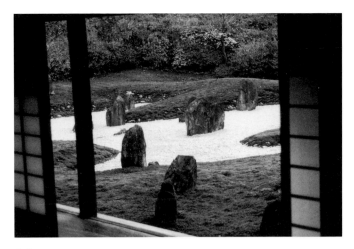

1-4.

What image does the client or designer want to project? For instance, spatial imagery and symbolism can easily be linked to

- A place that projects an image of power and success

- A space that demonstrates the importance of technology

- A plaza that embraces a river and celebrates water as a joyous life-giving element

- A neighborhood redevelopment that recognizes the importance of historic values

- A landscape that above all nurtures and protects the natural ecosystem

- An office complex projecting a message that the companies located there are concerned about conservation and protection of natural resources

- A provocative place that shocks, disturbs, surprises, or disorients the user

- A tranquil place for quiet reflection or meditation

- An entertaining environment where fun is paramount

- A place depicting humanitarian or philanthropic values

- A place that projects an image of progress and innovation

- A space that shows a sense of precision, grace, and simplicity

Once the designer identifies the philosophical concepts appropriate to site or client, then the challenge is to express those concepts in physical form. By idea association and brainstorming, a number of visual images may emerge. High-tech messages may suggest crisp lines, geometric shapes, and a dominance of man-made materials such as plastic, steel, and concrete. Valuing the environment may suggest organic forms and a dominance of soft materials such as grass, trees, and water. Places for entertainment may demand brightly colored moving elements, whereas a tranquil setting may call primarily for muted tones and static elements. Another abstract area of exploration that can add depth to concept development is the idea of mood. What type of mood best matches the more general goal or belief? The appropriate mood could be:

Serious, frivolous

Active, passive

Surprising, obvious

Introspective, extroverted

Cooperative, confrontational

Stimulating, soothing

Interactive, solitary

Then we can ask, what physical form or materials might evoke such a mood?

The following chapters contain many specific form suggestions adaptable to particular abstract ideas and to designed spaces that evolve from a philosophical basis. Most conceptual planning emphasizes the visual realm. Some interesting ideas, however, exploit the other senses as well. Consider the possibilities of engaging the sense of touch. A multitude of tactile experiences can be provided by including textures that are rough, smooth, soft, sharp, moist, hot, dry, bumpy. Although particularly appropriate in spaces designed for the visually impaired, they are too often ignored in all outdoor design. The same can be said

for olfactory, auditory, and kinesthetic experiences in the landscape. Fragrances have a powerful impact on mood. Sounds, especially if manipulated by the user, add an interesting dimension. Moving elements and bodily motion have tremendous potential for adding excitement to the landscape experience. Can the non-visual senses become part of the designed landscape imagery? Do they inspire design ideas?

In urban environments the stronger messages may be socioeconomic. Surveys, public participation, and sensitivity to community needs all contribute to a better understanding of the cultural environment. All contextual opportunities play a major role in molding the concept, a tenet at the core of landscape architectural education. By "listening" to the land and understanding the underlying site, the designer can discover specific opportunities and restrictions that should become part of the program and the concept.

SPECIFIC FUNCTIONAL CONCEPTS

Specific functional concepts relate to solving specific problems and can be expressed as conceptual objectives.

- To reduce erosion
- To eliminate poor drainage
- To control damage by animals
- To avoid vandalism
- To reduce the maintenance burden
- To keep within a specific budget

Solutions to these practical objectives may not have very clear spatial expressions but will ultimately have an impact on the final form. Most other functional concepts will be easy to diagram, especially those that deal with the relationships between use areas, circulation patterns, and other preliminary ideas essential to the workability of an emerging design.

Use areas and activity zones can be shown as amorphous blobs or bubbles, but before they can be drawn, their approximate size must be established. This step is important because when activity areas are manipulated within a scaled site plan, their quantitative values must be in correct proportion to each other. For example, for a parking lot for fifty cars, a quick approximation of spatial requirements for that many cars should be made.

Then the spatial needs can be abstracted into a bubble and easily manipulated by eye into one wraparound shape or split into two bubbles.

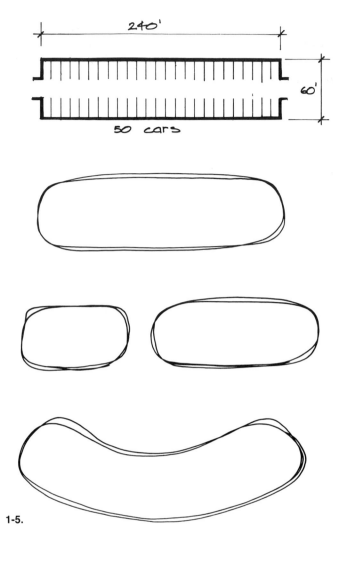

1-5.

Simple arrows can designate corridors and other directional movements. For clarity these arrows might have a hierarchy of size or shape to distinguish between major and minor corridors and different modes such as pedestrian and vehicular traffic.

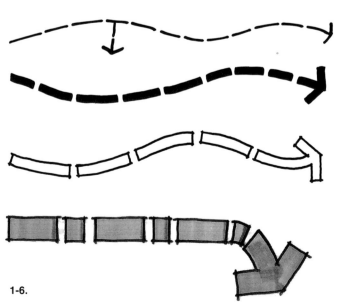

1-6.

Star or cross shapes can represent important focal points, activity nodes, potential points of conflict, and other compact elements with a high degree of significance.

1-7.

Jagged or articulating lines can show lineal vertical elements such as walls, screens, barriers, and embankments.

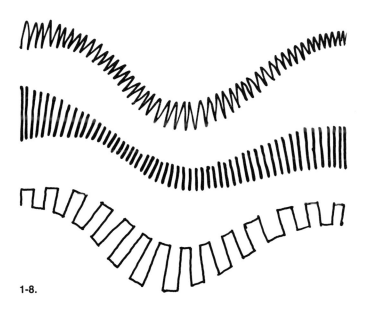

1-8.

At this stage of design development it is important to keep the symbols abstract and easy to draw. Being able quickly to reposition and reorganize helps to focus on the primary purpose of this process, which is to optimize the functional relationships between different use areas, resolve location problems, develop an effective circulation system, and answer questions about where things should be and how they might work together. Generalized spatial quality, whether sunken, raised, walled, canopied, sloped, or bermed, can also be explored in this functional concept phase.

Conceptual graphic symbols can be adapted to any scale. A residential example is shown in Figure 1-9.

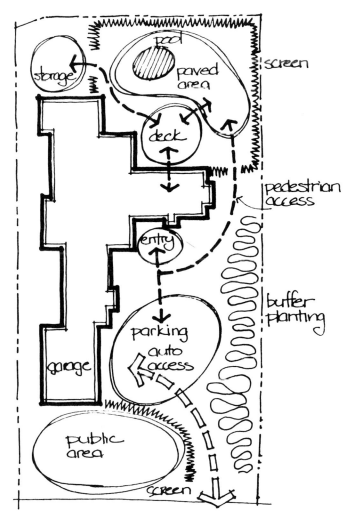

CONCEPT PLAN

1-9.

A further example of conceptual planning, a development for a community center, might have the following guidelines as a simplified written program:

- Locate the three major building elements in order to minimize disturbing the existing stream and vegetation.

- Include parking for 100 cars.

- Keep the automobile parking entrance as far away from the intersection as possible.

- Provide easy pedestrian access from adjacent streets.

- Include a multiuse plaza or amphitheater to accommodate occasional performances, outdoor classes, relaxation, art shows, sculpture displays, and so forth.

- Locate a sign to identify the facility.

- Provide an open grass area for unstructured recreation.

Such guidelines can be quickly and easily diagrammed beginning with a base plan of the site drawn to scale. Although not shown here, two important steps in the design process should precede the concept diagram: a site inventory records all the existing conditions and a site analysis records the designer's opinions and evaluations of these conditions. A sheet of tracing paper taped over the scaled inventory and analysis plan is an efficient way to initiate the concept diagram. Such a procedure allows the information about the site and the written program to be considered together.

Figure 1-10 shows the existing site conditions of the future community center site. Figures 1-11 and 1-12 show two alternative concepts for its development. For both concepts all of the program requirements have been satisfied and the existing site conditions recognized, yet the concepts are very different from each other. A careful comparison of the alternatives reveals the advantages and disadvantages of each and allows an informed choice of the better scheme.

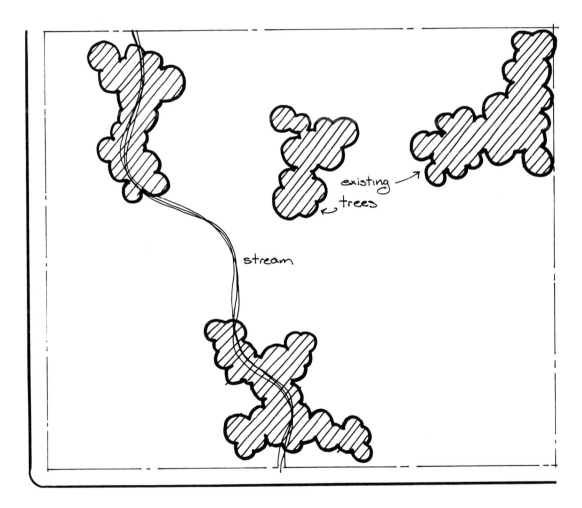

existing trees

stream

1-10.

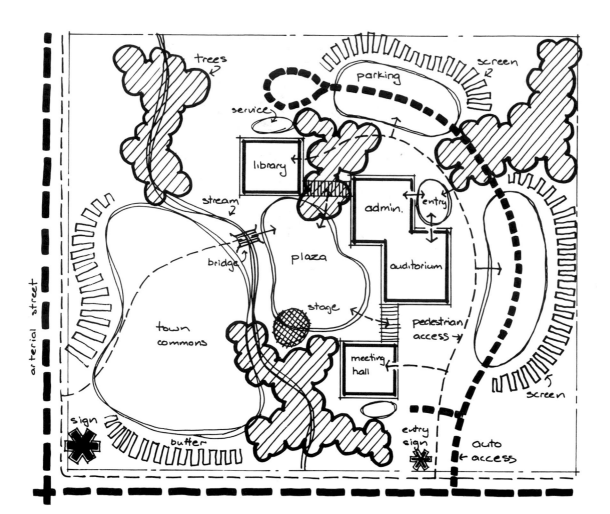

Labels within the image: trees, screen, parking, service, library, stream, admin., entry, auditorium, plaza, bridge, town commons, stage, pedestrian access, meeting hall, screen, sign, buffer, entry sign, auto access, arterial street

1-11.

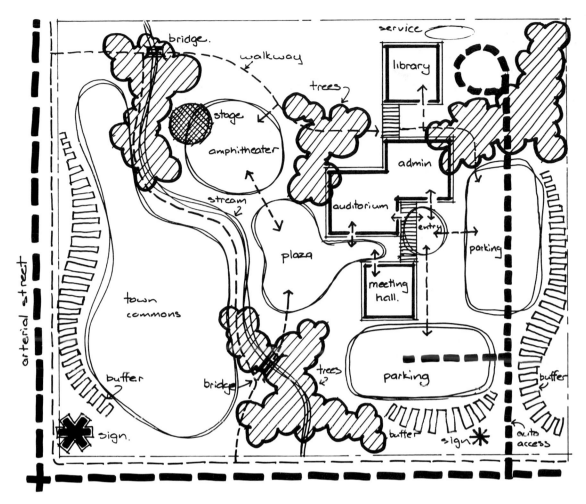

When developing the concepts, it is best to avoid the temptation to introduce specific forms and shapes. At this stage the lines of the amorphous bubbles represent the approximate limits of a use area (for example, a multiuse plaza), not the exact edge of a specific material or object. The directional arrows represent corridors of movement, not the edge of a walk or roadway.

There can be an indication of types of surface-covering materials such as hardscape, water, open turf, and planted areas; but there is no need to get sidetracked into details of color, texture, pattern, and form. If part of a site demands more complex treatment, it may be necessary to refine the concept plan just for this portion.

At this planning stage of the design process, the first conceptual level of organization has been applied to the site. Future refinements of this same site will be shown in Chapter 2 as we move from concept to form by applying another level of organization.

The jump from concept to form can be viewed as an organized process of refinement whereby the loose blobs and arrows of the concept plan are transformed into specific shapes. Recognizable objects appear, realistic spaces evolve, precise edges are drawn, and actual material types, colors, and textures are chosen. How these elements can be creatively manipulated is explained in detail later in this chapter. But first it is important to understand their essential characteristics.

BASIC ELEMENTS OF DESIGN

In this analysis the basic elements of design are identified as ten distinct entities. The first seven are primarily visual. They are point, line, plane, form, motion, color, and texture.

Point A simple dot is a place in space without dimension.

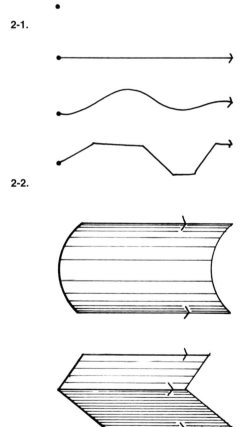

2-1.

Line When a point is displaced or moved, the result is a one-dimensional line.

2-2.

Plane When a line is displaced, the result is a two-dimensional plane or surface but still with no thickness. The configuration on this surface is its shape.

2-3.

Form When a plane is displaced, the result is a three-dimensional form. Form can be viewed as a solid object or as a void surrounded by planes.

Outdoor space receives its form from the planes of surrounding objects defined by vertical, horizontal, or warped planes, just as a room takes its form from walls, floor, and ceiling. By definition some planes in an outdoor space are either totally open or partially open to allow penetration of light, air, rain, and other natural conditions.

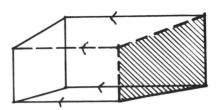

2-4.

Motion When a three-dimensional form is moved, motion is perceived, bringing in the fourth dimension, time, as a design element. Motion here, however, should be considered in relation to the observer. As we move through space, objects appear to pass in front of each other, get smaller or bigger, pass out of and into view, change in detail, and so on. In the design of outdoor space it is these perceptions of the moving observer that have a greater significance than the perceptions of moving objects as seen by the stationary observer.

Color All surfaces have some inherent color, which is perception of different light wavelengths.

Texture The characteristic of surface resulting from the existence of repetitive points or lines makes patterns that visually are relatively coarse or fine, or felt as tactile qualities of texture described under touch. Textures also result from edges of many repeated forms or abrupt transitions between color and reflections.

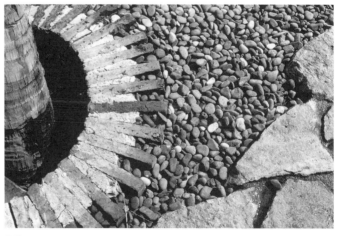

2-5.

The remaining three elements relate to the nonvisual senses.

Sound—auditory perception Having a profound effect on the way we experience space, sounds can be loud or soft, natural or artificial, pleasant or noisy, and so on.

Fragrance—olfactory perception In landscape design the scent of flowers, leaves, or needles most often stimulates our sense of smell, but a wide range of pleasant and unpleasant olfactory perceptions exist.

Touch—tactile and kinesthetic perception Through skin contact we receive a variety of sensations—hot and cold, smooth and rough, sharp and blunt, soft and hard, wet and dry, sticky, malleable, and so on.

Manipulation of these design elements provides a diverse range of opportunities for the designer, who selects or develops creative forms to fit the unique opportunities of each site and client.

This chapter explores a variety of forms along with the process that evolves from the conceptual scheme. The categories of form discussed here are the most common and useful in design, but they are by no means the only options. They are merely a basic palette to be expanded upon by a designer's own inventiveness.

The process of form development draws upon two very different ways of thinking. One is based on logic and the use of *geometric forms* as guiding themes. The components, connections, and relationships follow strict laws of order inherent within the mathematics of the various geometric shapes. Using this approach can result in powerful unified spaces.

But to the pure romanticists, the geometric might appear dull, boring, ugly, and oppressive. Their way of thinking is to bring meaning to the design through a more intuitive, irrational approach using *naturalistic forms*. Shapes may appear erratic, frivolous, whimsical, and random but will likely have more appeal to the pleasure-seeking, adventurous side of the user.

Both modes have inherent structure and need not be distinguished from one another by structure alone. For instance, part of the joy of randomness is the pleasure of seeing some aspect of pure order, like the circle, but not being able to totally resolve the variety, as in a randomly circular cluster of bubbles.

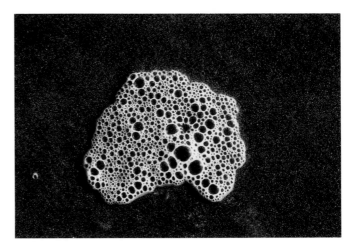

2-6.

GEOMETRIC FORM

One useful principle of organization is repetition. If we take simple geometric or mathematically derived shapes and repeat them in a systematic manner, the resulting overall form will likely exhibit a powerful unity. By varying size and location, an interesting variety of forms evolves from even the most basic shapes.

The starting point for geometric form is the three primary shapes.

- The square
- The triangle
- The circle

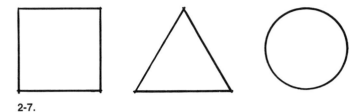

2-7.

From each primary shape derive subthemes: from the square, the 90° rectangular theme standing alone; from the triangle, the 45°/90° and the 30°/60° angular themes; from the circle, a variety. The most common include circles on circles, circles and radii, circles and tangents, circle segments, the ellipse, and the spiral.

The 90° Rectangular Theme

By far the simplest and most useful of all, the 90° rectangular theme relates to many building materials and adapts easily to construction methods. The square or rectangle is perhaps the most ubiquitous organizing theme in the built environment because developing form from it is fairly easy.

A 90° grid pattern as an underlay of the concept plan allows a functional diagram to be easily reorganized. The approximate shapes of the concept are redrawn by following the 90° grid as a structuring guide.

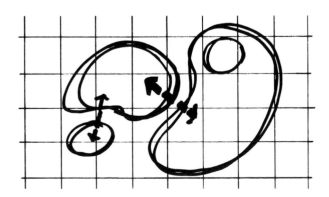

2-8.

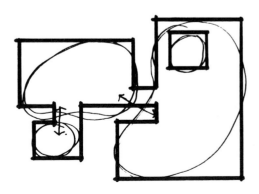

2-9.

The areas thus newly outlined, all boxlike shapes with 90° corners and opposite sides parallel, then have a different meaning. Whereas the contours of the bubbles and arrows within the concept plan represent abstract ideas such as functional zones and corridors of movement, the redrawn lines represent real objects. They now become edges of objects, show changes from one material to another, or illustrate abrupt level alterations.

2-10.

The directional arrow symbols indicated by one line on the concept plan become two lines representing the edges of the walkway.

The screen symbol becomes a double line representing each side of a brick wall, and the focus symbol becomes a small fountain.

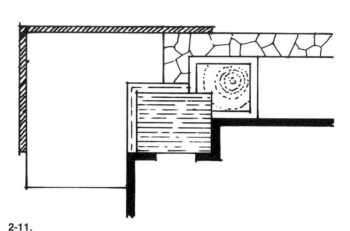

2-11.

The 90° theme, the easiest to develop in conjunction with axial symmetry, is often used as the structural basis for expressing a sense of formality. Although simple in structure, rectangular forms can also result in very interesting informal spaces, especially when two-dimensional forms extend vertically into the third dimension. As shapes are depressed or raised through steps and walls, the level changes reinforce spatial qualities. The following illustrate rectangular plans and how similar forms can provide a structure for the walls, roofs, and even site furnishings.

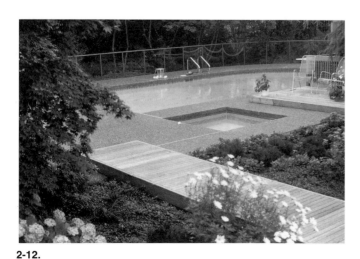

2-12.

2-13.

2-14.

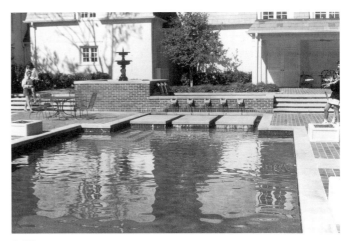

2-15.

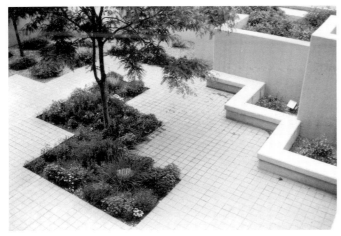

2-16.

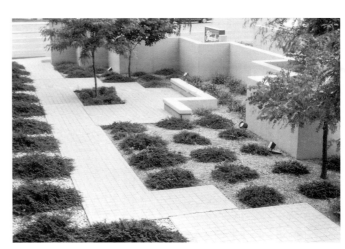

2-17.

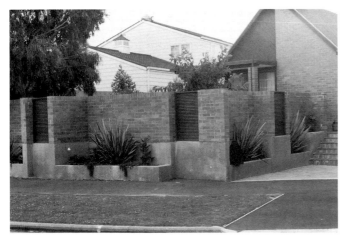

2-18.

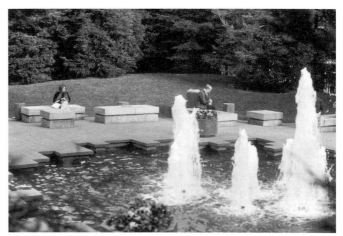

2-19.

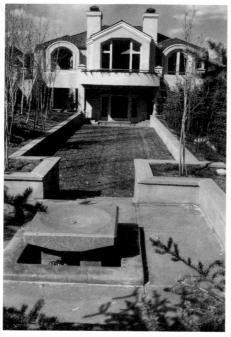

2-20.

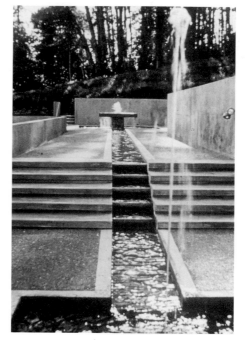

2-21.

Angular Themes

The 45°/90° Angular Theme

Here again it is possible to use a prepared guide pattern to structure the jump from concept to form. Two rectangular grids placed at 45° angles to each other serve as the basic theme. To show comparisons between the different forms, the same concept plan used in the rectangular theme has been used here. This time it is overlaid upon the 45°/90° grid.

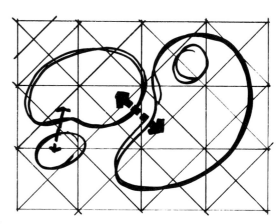

2-22.

Redrawing the lines to represent edges of objects or material and level changes becomes a simple process. Because the pattern underneath is just a guide, it is not necessary to draw exactly on top of the grid lines. It is important, however, to respect the pattern and draw lines parallel to the underlying grid.

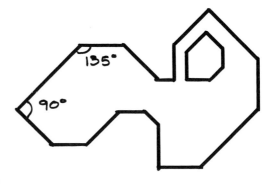

2-23.

One Note of Caution When changing direction by 90° or 45°, inside angles should be 90° or 135°. The acute angle of 45° can often yield nonfunctional spaces, areas that can become a maintenance problem and corners that are hazardous or not structurally sound.

2-25.

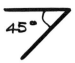

2-24.

This planter corner shows signs of damage due to the sharp angle.

2-26.

Angular themes tend to be dynamic and bring a sense of action and movement to a space, enhanced through level change and the use of angular vertical elements.

The following illustrations show the total spatial impact produced by the 45°/90° angular theme.

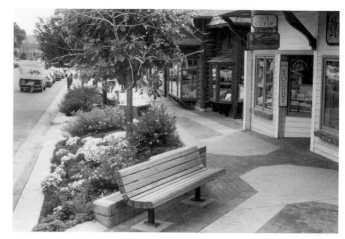

2-27.

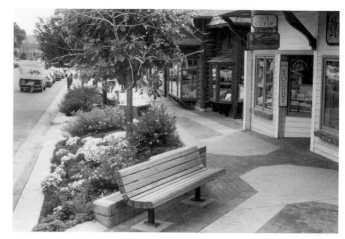

2-28.

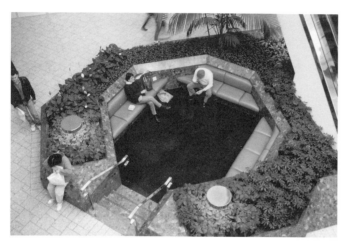

2-29.

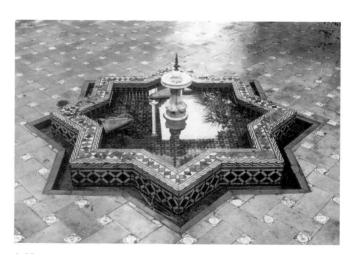

2-30.

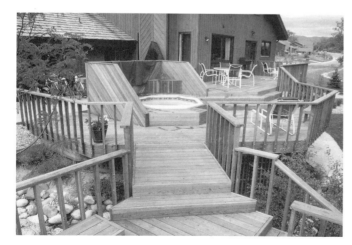

2-31.

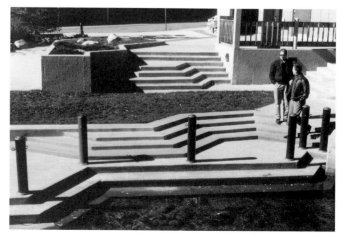

2-32.

The 30°/60° Angular Theme

As a guide pattern the 30°/60° theme might look like this illustration and can be formed and used in the same manner as the previous two patterns:

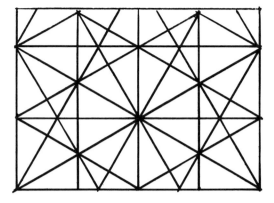

2-33.

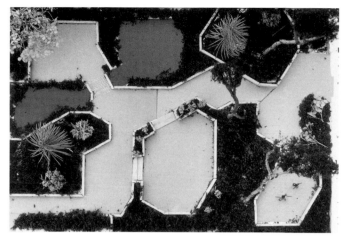

2-34.

If the multitude of directional lines becomes confusing, try organizing the spaces on a hexagonal basis, a little more rigid but with the same geometrics as the 30°/60° angle grid. Use a hexagon template or trace hexagons from the appendix.

An easy way to construct a hexagon, where the length of each side is the determining factor, is to scribe a circle with a radius. Take the same radius setting on the compass and move the compass point to the circle. Then mark equal lengths around the circle to end up where you started.

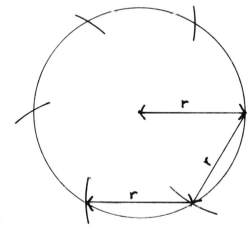

2-35.

Join the marks to form a hexagon.

The fourth section in the Appendix gives instructions on drawing a hexagon where the distance across the hexagon is the determining factor.

2-36.

Duplicate a hexagon at the same size or at different sizes according to the spatial needs suggested in the concept plan. Also, if indicated by the concept plan, bring the hexagons together so that they touch, overlap, or fit inside each other. To maintain the unity of the composition avoid rotation.

Let the concept plan suggest locations and spatial arrangement.

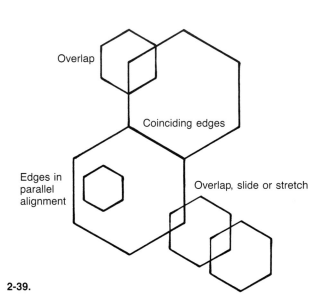

2-37.

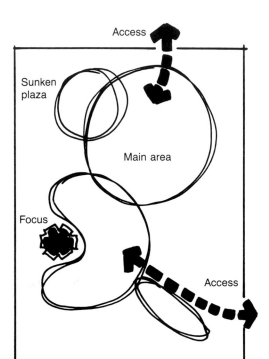

2-38.

2-39.

Simplify the composition by omitting lines, outlining spaces, or adding connections to make the spaces work. Remember that the lines now represent edges of materials.

2-40.

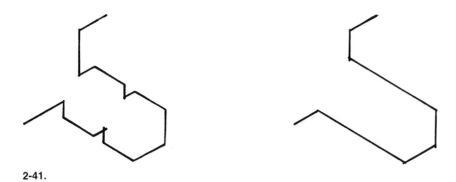

2-41.

Avoid acute 60° and 30° angles. As with the 45° angles, these can result in uncomfortable, unmanageable, or dangerous corners. For example, simplify the space as shown in figure 2-41.

Exploit the three-dimensional spatial potential by raising or lowering areas, projecting vertical elements, or developing overhead structures if desirable. Add furnishings and other site amenities to humanize the space.

2-42.

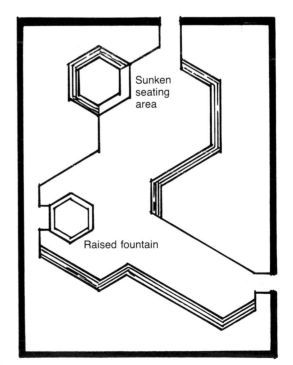

Sunken seating area

Raised fountain

2-43.

There are many other possible configurations using the hexagon.

2-44. Spiral placement.

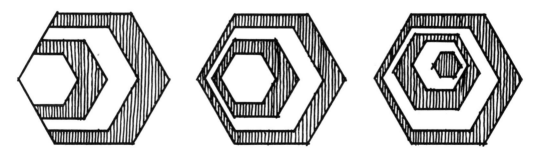

2-45. Eccentric placement.

The following illustrations demonstrate the interesting variety of spatial expression possible using the 30°/60° angles as the organizing theme.

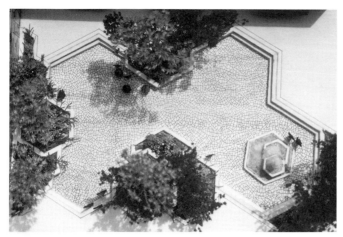

2-46.

2-47.

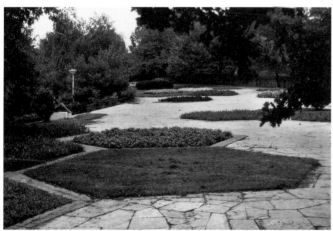

2-48.

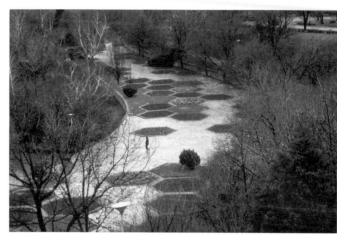

2-49.

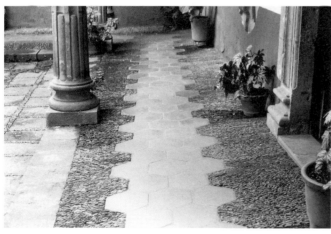

2-50.

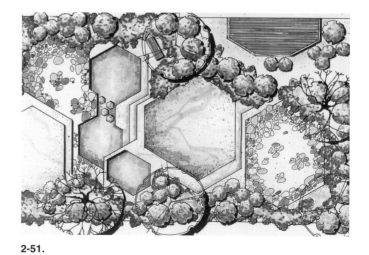

2-51.

Before leaving the straight-line themes, consider some of the possibilities that use distorted grids as opposed to simple geometric angles.

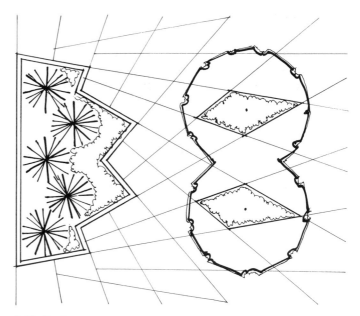

2-52. Radiating grids.

These can create interesting perspective illusions when used on the ground plane.

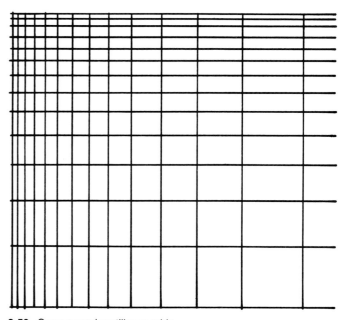

2-53. Compressed rectilinear grids.

Circular Themes

The power of the circle lies in its simplicity, its feeling of complete unity and wholeness. Yet it also symbolizes the duality of motion and stillness. As expressed by Benjamin Hoff (1981), "The unmoving leg of the compass makes the perfect circle possible."

A space designed on the basis of one pure circle will project both simplicity and power, but a multitude of manipulations is possible beyond the single pure circle.

2-54.

Circles on Circles

Here the basic theme is to place circles of various sizes inside each other or so that they overlap.

Start with the basic form of the circle.

Duplicate it; enlarge it; reduce it.

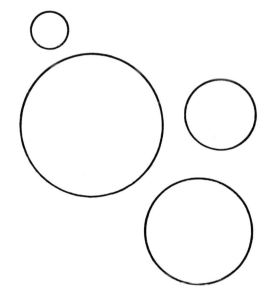

2-55.

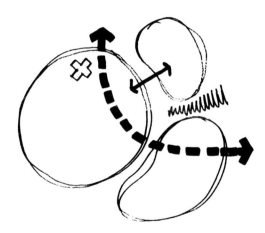

2-56.

Let the concept determine the number, size, and location of circles to use. Where necessary place circles within each other to suggest a different object or material.

When overlapping, adjust the circles so that the arcs intersect at nearly 90° to give the strongest visual connection between the circles.

2-57.

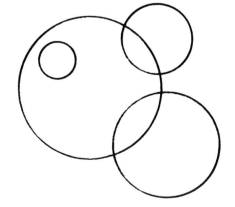

Avoid small overlaps, which give rise to acute angles. Also avoid touching circles unless the flow of the spatial edge continues in an S shape. A reversal at the contact point again sets up very sharp angles.

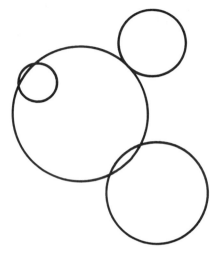

2-58.

2-59.

Simplify the composition by omitting lines, outlining, and adding connections to noncircular surroundings. Straight connections such as pathways or corridors with parallel edges should be designed with their centerlines aligning with the circles' centers.

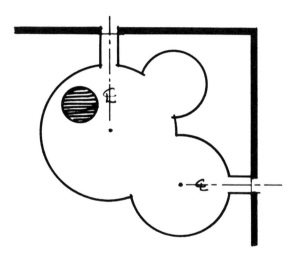

2-60.

This aerial view of a hotel plaza shows four circular landscape elements. They are a pool, a raised platform, a thatched umbrella, and a moated pergola. Although separate, they are unified by the paving and walkways.

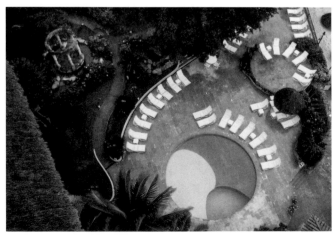

2-61.

The paving around the deep edge of the pool is skill-
fully warped upward to form a bridge.

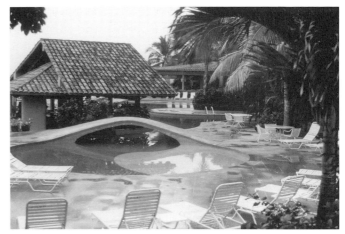

2-62.

The most compatible volumetric forms in this type of
plan organization are cylinders and spheres.

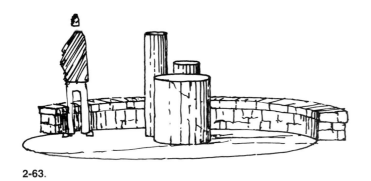

2-63.

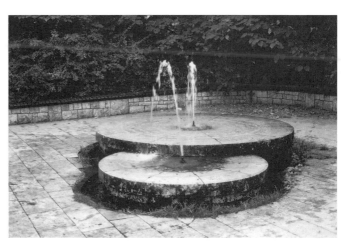

2-64.

2-65.

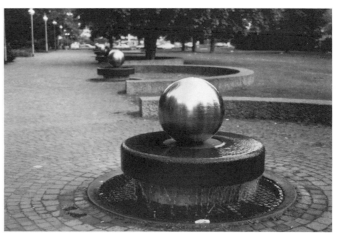

2-66.

In the following illustrations, find the parts of circles that make up each whole composition. Also look for level changes, steps, walls, and other three-dimensional spatial expressions.

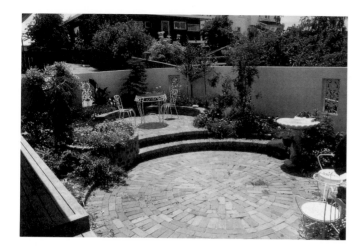

2-67.

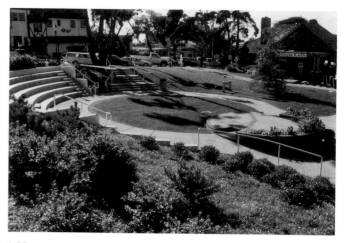

2-68.

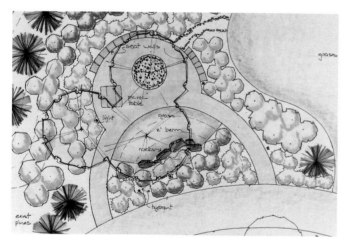

2-69.

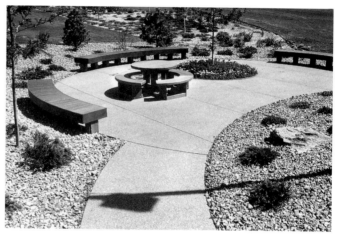

2-70.

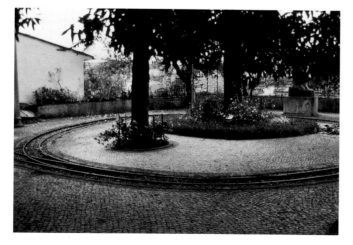

2-71.

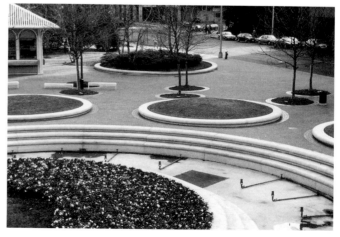

2-72.

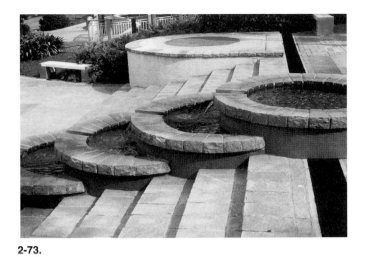

2-73.

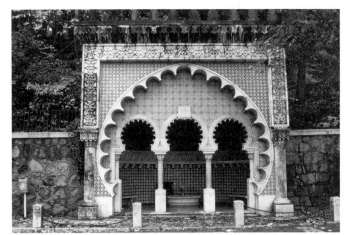

2-74.

A variation would be to explore eccentric positioning of the circles.

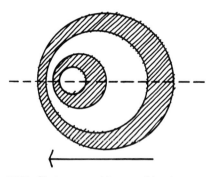

2-75. Circles moved to one side along an axis.

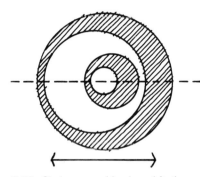

2-76. Circles moved back and forth along an axis.

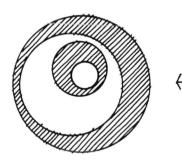

2-77. Circles moved along several axes.

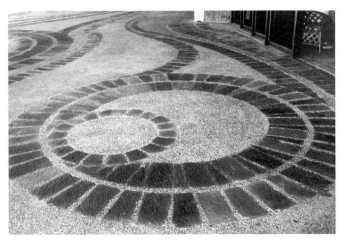

2-78.

Concentric Circles and Radii

As before, begin with a concept plan.

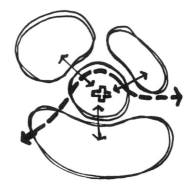

Prepare a "spider web" grid, this time by combining radius lines with concentric circles (see Appendix). **2-79.**

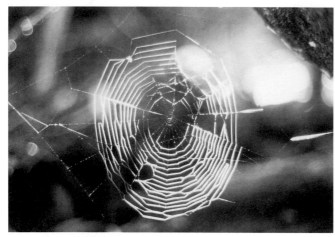

2-80.

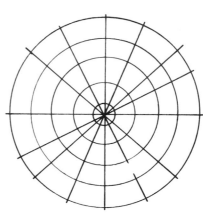

2-81.

Overlay this grid with the concept plan.

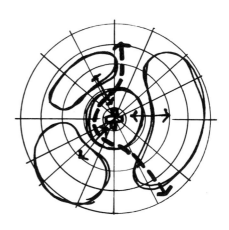

2-82.

Then develop the spatial form by following the character of the web theme, letting the concept plan guide size and location. The lines you draw may not be on top of a grid line, but they must relate to the center point by being either a radial line or a concentric arc.

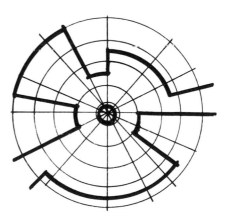

2-83.

Simplify the composition by omitting lines. Add connections to form 90° angles with the surrounding elements.

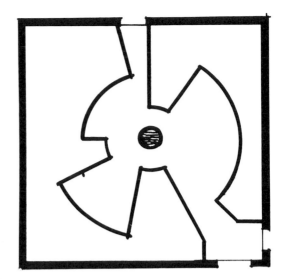

2-84.

The following illustrations show examples of radius and concentric circular designs. Note how the center adapts well to location of focal elements.

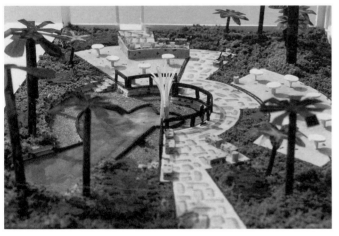

2-85.

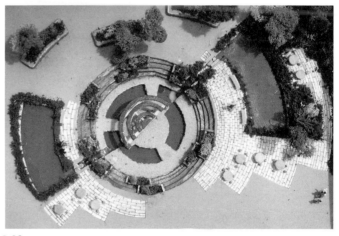

2-86.

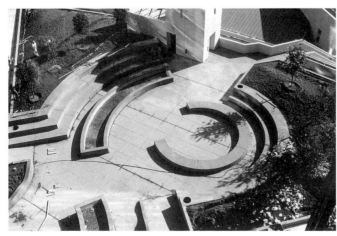

2-87.

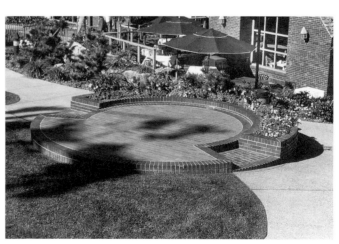

2-88.

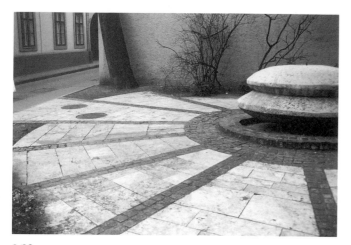

2-89.

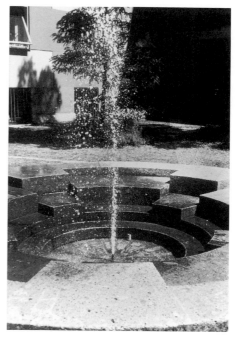

2-90.

Arcs and Tangents

The next shapes use arcs and tangents as the basic theme.

The straight line which touches the edge of a circle meets the radius at 90° and is a tangent line.

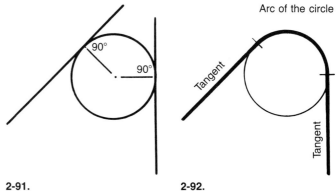

2-91.　　　　　　　　**2-92.**

Begin by enclosing areas of the concept plan with boxlike shapes.

2-93.

Add circles of various sizes at the corners so that the edges of each circle touch the straight lines.

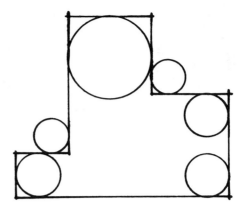

2-94.

Trace around the edges to form a linked series of arcs and tangents.

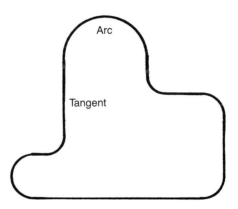

Arc

Tangent

2-95.

The usual finishing touches of simplification and adding connections may be necessary to blend the composition with surrounding forms.

Refine the design by adding materials and facilities to match the client's needs.

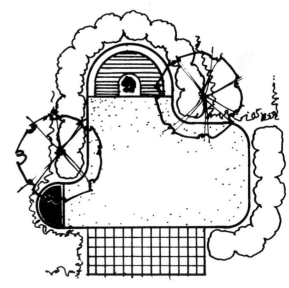

2-96.

If the original boxlike forms were too restricting, another step may be necessary before detailing materials.

The same circles as illustrated above may be pushed in various directions. Reconnect them with tangents so that the design form appears like a belt going around wheels.

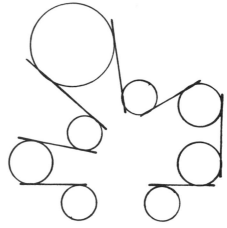

2-97.

The final result is a relaxed flowing form with a hint of formality and crispness, as in the following examples.

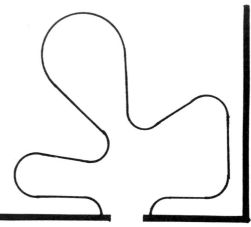

2-98.

2-99.

2-100.

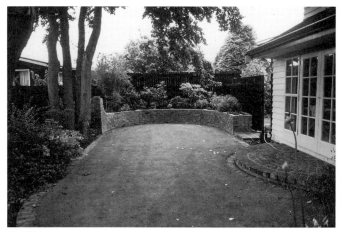

2-101.

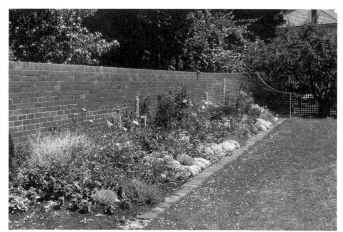

2-102.

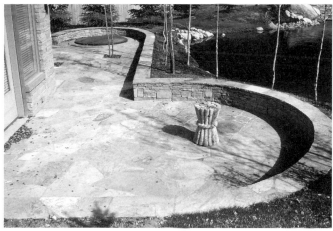

2-103.

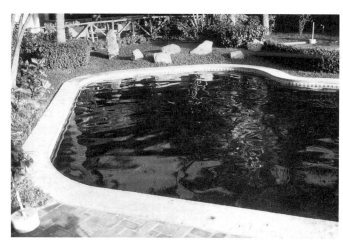

2-104.

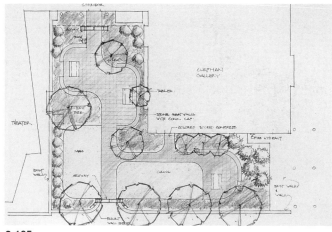

2-105.

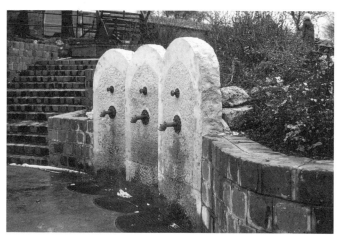

2-106.

Circle Segments

Here the circle is divided into semicircular or quarter-circle, pie-shaped segments and reorganized along the horizontal and vertical axes.

Start with the basic form of the circle. Divide it into segments. Separate them (see Appendix).

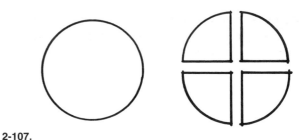

2-107.

These may now be duplicated, enlarged, or reduced.

Let the concept plan suggest the number, size, and location of the segments.

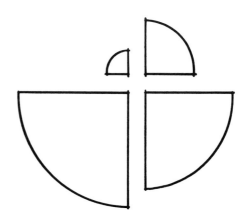

2-108.

2-109.

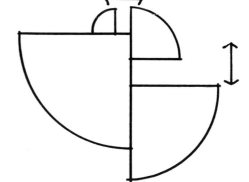

Recombine the segments by sliding segments along coinciding edges or offsetting the parallel edges.

2-110.

Simplify the composition by outlining and omitting unnecessary lines. Add connections or openings to make the spaces work.

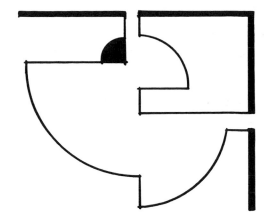

2-111.

Refine and embellish the space with the appropriate materials and level changes.

2-112.

Look for the circle segment theme in the following illustrations.

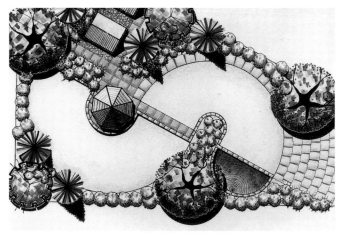

2-113. Garden plan.

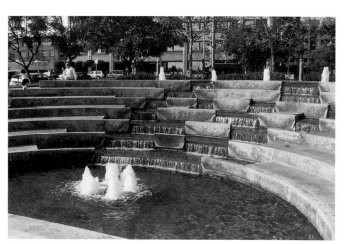

2-114. Urban plaza, San Diego, California.

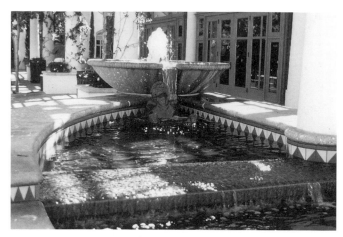

2-115. Fountain, Del Mar, California.

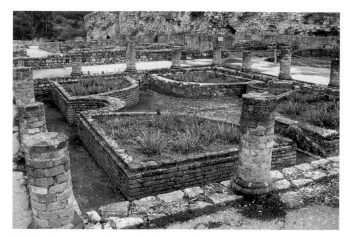

2-116. Roman courtyard, Conimbriga, Portugal.

The Ellipse

The same principles of form evolution described in the section "Circles on Circles" can be used with elliptical or oval shapes. Ellipses can be used alone, ovals on ovals, or they easily mix with circles.

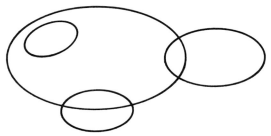

2-117.

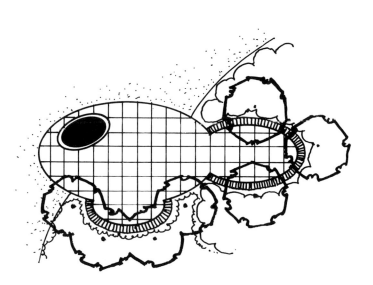

2-118.

In mathematical terms the ellipse is derived from planes that intersect cones or cylinders. The intersections are at set angles not parallel to the main vertical and horizontal axes.

Visualize ellipses as flattened circles. The easiest way to draw geometrically exact ellipses is to use an ellipse template. However, your template may not have the correct sizes, or it may produce ellipses too flattened or too rounded for the spaces you wish to create. Instructions for constructing customized ellipses can be found in the Appendix.

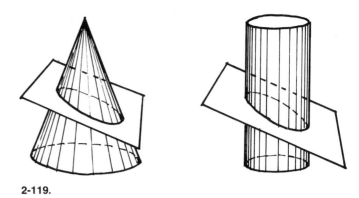

2-119.

The ellipse produces a more dynamic feel than the circle yet still retains the formality of strict mathematical order as seen in the following examples.

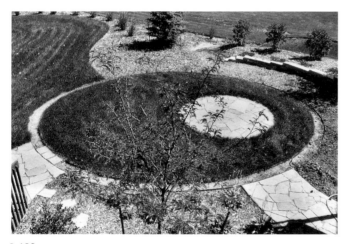

2-120.

2-121.

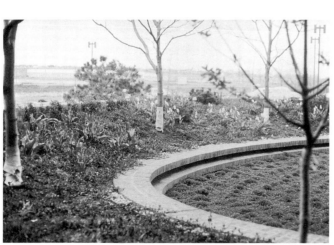

2-122.

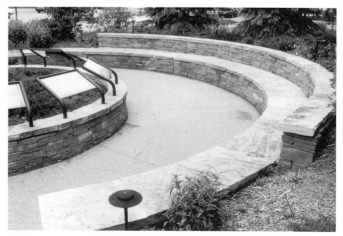

2-123.

The Spiral

If an exact logarithmic spiral is needed, it can be geometrically generated from a golden mean rectangle (see also Appendix).

Reduce the golden mean rectangle to a square on its shorter side. This leaves another golden mean rectangle whose longer side is now equal to the previous shorter side. Continue the process of diminution as far as practical then scribe a series of arcs within each square, as shown, to form a spiral (Critchlow, 1970).

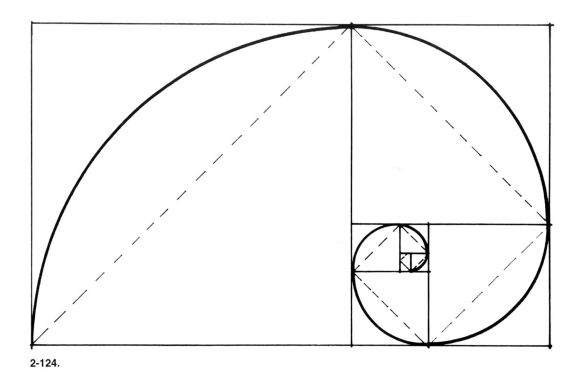

2-124.

Although the mathematical spiral has a fascinating precision, it is the freehand expression of the spiral or the *free spiral* that probably has more application in landscape design. Further discussion of the free spiral appears later in this chapter.

To summarize the application of geometric form to site design, a single concept plan for a community plaza has been developed into various themes. Each has the identical elements of a sunken stage with a small moat, a main plaza with seating, a bridge, and the essential access ways. The illustrations show the different spatial feelings possible when design incorporates these rather formal geometric themes as guiding organizational patterns.

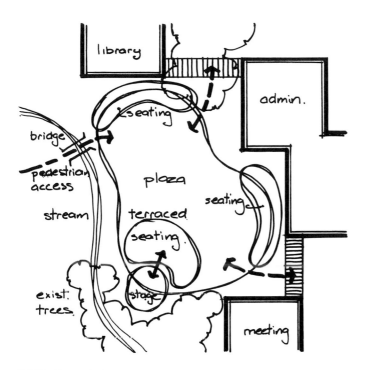

2-125. Concept plan.

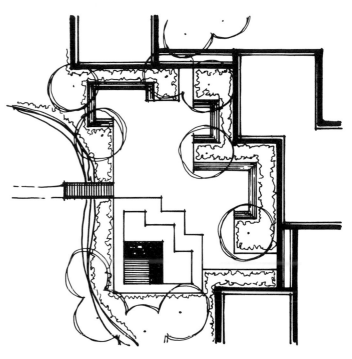

2-126. 90° rectangular theme.

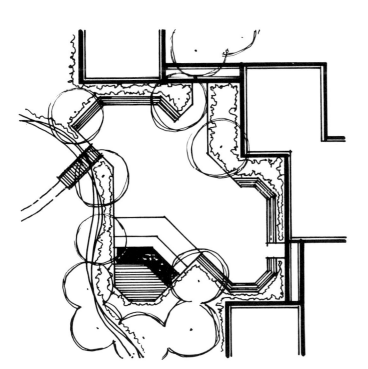

2-127. 45°/90° angular theme.

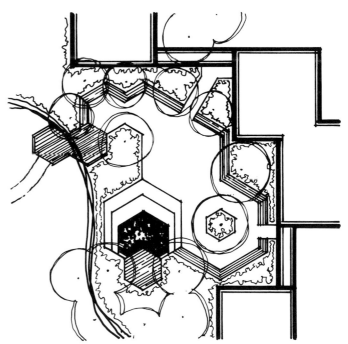

2-128. 30°/60° angular theme.

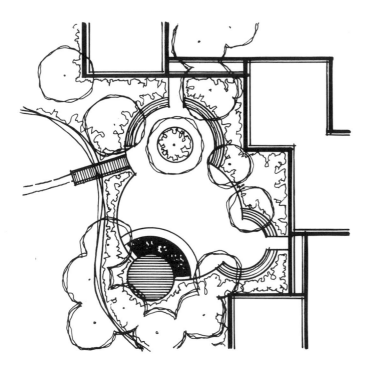

2-129. Circles on circles theme.

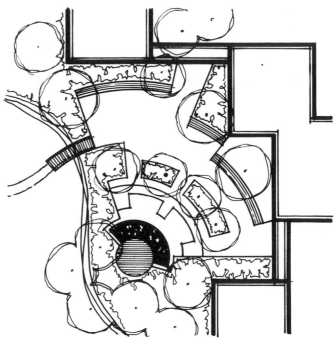

2-130. Circles and radii theme.

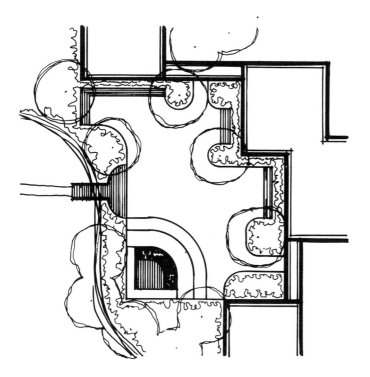

2-131. Arcs and tangents theme.

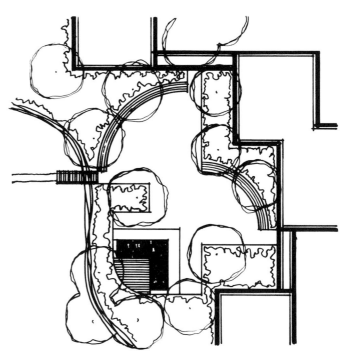

2-132. Circle segments theme.

NATURALISTIC FORM

During the research phase of a project, when information and impressions are being assembled about the site and the user, it may become evident that a naturalistic feeling should be pursued to develop the design. For a number of reasons the designer may decide that the strictly disciplined shape of a pure geometric form may be less appropriate than a looser, more organic form. The site itself may suggest this. Landscapes that originally show little disturbance by man or that contain elements of natural interest may be more receptive to changes that reincorporate the materials and forms of nature.

In other situations this inclination toward a naturalistic approach may stem from the needs, desires, or aspirations of the user independent of the existing site conditions. Indeed the site may be a rigid urban environment composed of harsh man-made elements. Yet the client may wish for something new that appears looser, softer, freer, more naturalistic. Similarly, businesses may wish to project an image of environmental consciousness. They may want the public to think that their products promote ecological awareness or that their services enhance conservation of natural resources. Consequently, the designer's program and conceptual base ultimately transform some connection to nature into design.

The strength of the relationship between the built environment and the natural environment depends on the designer's approach and the inherent existing site conditions. This connection to nature may be considered at three levels.

The first level is the essence of ecological design. Not only are the basic processes of nature recognized but the resulting design requires that human actions be integrated with minimal impact on the ecology of a site or that human actions have a regenerative impact. When, for instance, a wetland habitat is recreated from a degraded site or when a series of buildings is made to fit unobtrusively into a site with all the underlying natural processes intact, then the resulting forms display a true harmony with nature.

The second level creates the feeling of a naturalistic setting when the benefit of a complete system of natural processes is lacking. Artificial controls such as pumps and recirculating water, irrigation systems keeping plants healthy, or pipes and drains to control erosion, replace nature in most urban environments. Still, the emphasis is on the use of natural materials like plants, water, and rock arranged in patterns that reflect a natural order.

In the third level the connection to nature is more tenuous. In designed space largely devoid of any semblance to natural processes, composed predominantly of materials crafted by man—such as concrete, glass, brick, and timber—the imagery makes the connection. Shapes and forms must imply a natural order within this artificial framework.

Within the realm of nature imagery lies a rich palette of form ideas to use in design. These forms may be imitations, abstractions, or analogues of nature.

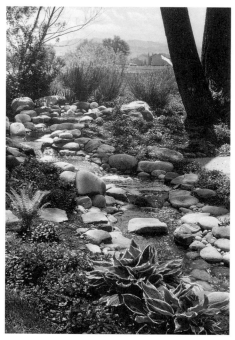

An *imitation* copies or mimics the shapes of nature without significant alteration. A recirculating man-made stream may appear very similar to a mountain stream.

2-133.

An *abstraction*, on the other hand, is the natural form used as inspiration and adapted or interpreted by the designer to suit a particular condition. In its final form it may bear little resemblance to the original object. Thus the smooth-flowing line in the landscape feels naturalistic but might not be recognized as having been derived from the meandering river.

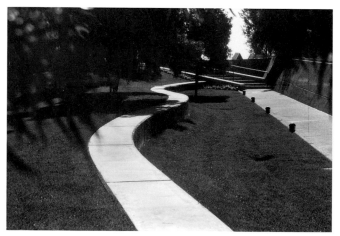

2-134.

An *analogue* is a form that accommodates an essential natural process but is free from the constraints of having to bear any visual resemblance. There occurs a functional analogy between the two. A drain that directs the flow of water across pavement is an analogue of the stream but looks very different.

2-135.

In the following pages examples of imitations and abstractions of nature are explored in more detail. One note of clarification is necessary before going any further. A distinction made here between *geometric forms* and *naturalistic forms* and between the different design impacts of each does not imply that they are separate and mutually exclusive categories. Indeed, the natural world displays a myriad of mathematical and geometric systems of order. Examples are the hexagonal pockets made by the honey bee, the radial symmetry of most flowers, and the strict spiral order of the DNA helix. There is a special branch of mathematics called fractal geometry that deals with the less regular shapes of nature. But for our purposes it is convenient to think of naturalism as displaying irregularity instead of exact duplication, asymmetry instead of symmetry, randomness instead of predictability, and looseness as opposed to rigidity and parallelism.

Taken together informal organic shapes evoke images of growth, process, frivolity, and freedom.

The Meander

Just as the square is the most common organizing theme in the built environment, perhaps the most ubiquitous natural form used in landscape site design is the meander, found in many natural realms.

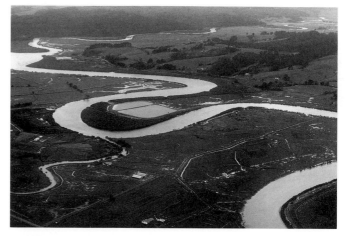

2-136.

The smooth back-and-forth flowing alignment of a riverbed shows the meander's essential form, characterized by gentle transitions from one curve to the next with no straight lines.

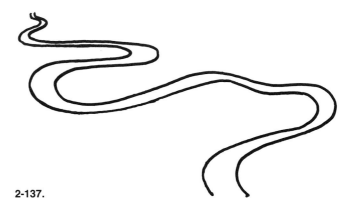

2-137.

In a functional context, this meandering shape is the preferred form for landscape elements such as roads or walkways designed to accommodate a smooth flow of vehicular or pedestrian traffic.

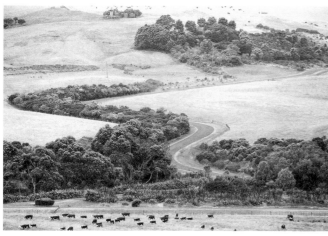

2-138.

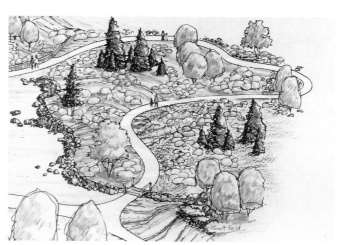

2-139.

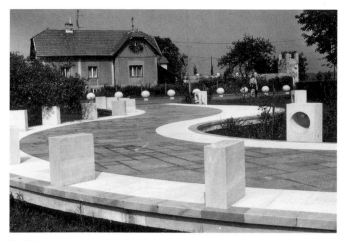

2-140.

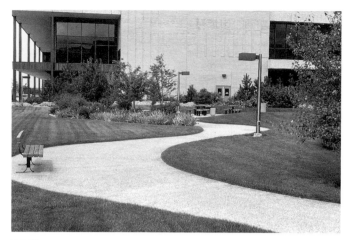

2-141.

In a spatial context, the meander often contributes to a sense of mystery. Viewed from eye level, the lineal space occupied by a meander seems to disappear from view and then reappear, behind subtle elevation changes and vertical elements.

This model of a bridge is patterned after the irregular meander. It contradicts the normal bridge design criteria of shortest and most direct route.

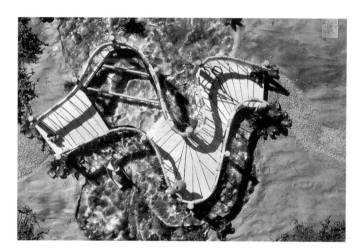

2-142.

Although not a functional pathway, this cobbled meander at the Singapore airport implies a feeling of gentle motion and disappears behind the grassy mounds.

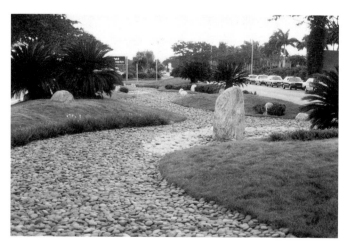

2-143.

A fairly regular undulation may express a meandering form, similar to the receding waters of this tidal inlet's wavelike pattern worn in the mud.

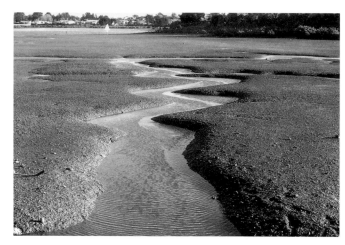

2-144.

A similar but somewhat more exacting regularity occurs in these wavelike walkways.

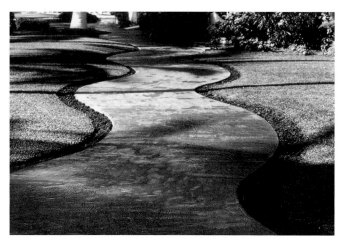

2-145.

2-146.

A variation of the meander exists in this fracture line in a tree trunk. The following examples of pavement and grass edging illustrate how the designer, by adding variety to the meander, creates an interesting rhythm in the flowing forms.

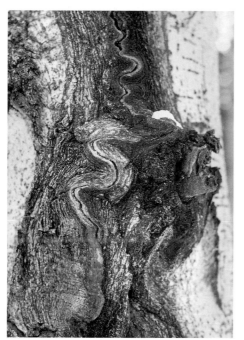

2-147. Natural fracture.

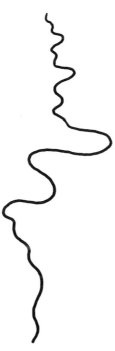

2-148. The essential form.

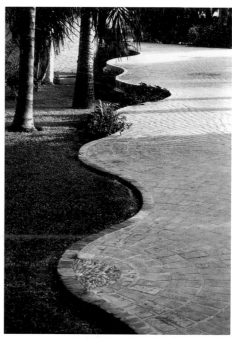

2-149. Its imitation in design.

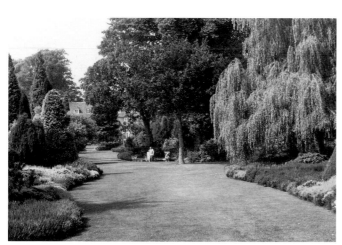

2-150.

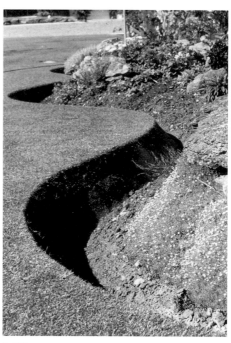

2-151.

Notice the strengthened impact of the horizontal plane meander projected up from ground level. In these examples hedges and seat walls express the meander.

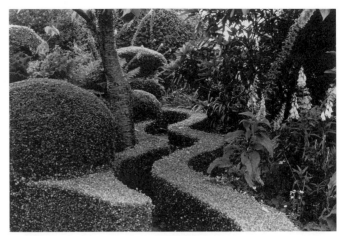

2-152.

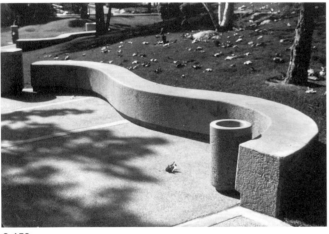

2-153.

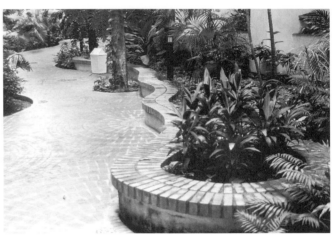

2-154.

Now consider the meander as a vertical plane form. Instead of a side-to-side flow, it becomes an up-and-down flow. The top of a wall or the upward undulations and mounding of ground elements can express the vertical meander.

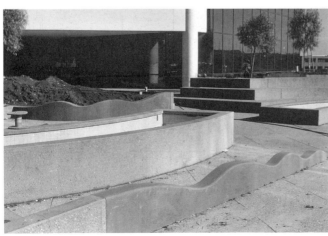

2-155.

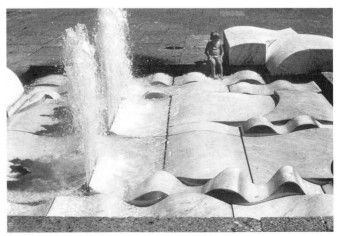

2-156.

Some bark patterns possess a wavy character, although usually with more subtle bends.

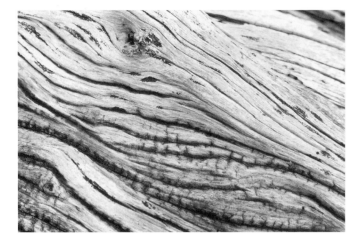

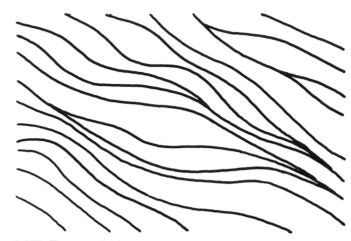

2-158. The essential form.

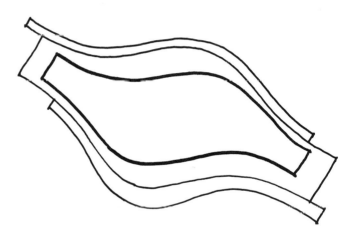

2-159. Designer's abstraction.

Abstracting such subtle bends one step further produces a gently bending pool and deck with level changes or lends a flowing pattern to bricks set in concrete.

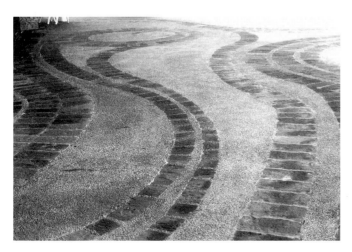

2-160.

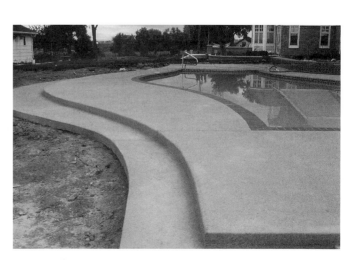

2-161. Its expression in the built landscape.

As ice freezes around trapped air bubbles, an interesting family of smooth lines develops. With a flowing character similar to lineal forms, the lines loop around to form a closed meander.

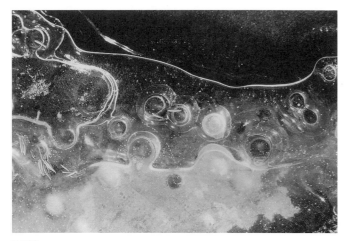

2-162.

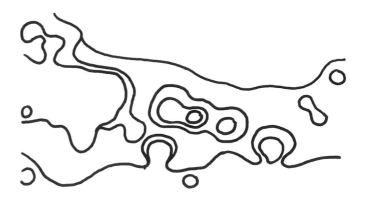

2-163.

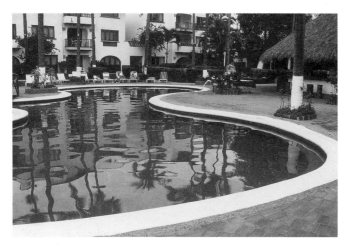

2-164.

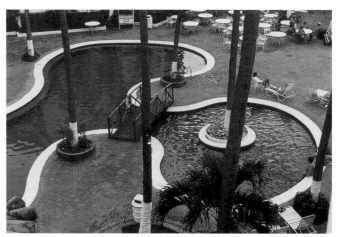

2-165.

Closed meanders, when expressed in landscape materials, could form the edge of contained turf areas, water features, or drifts of plantings.

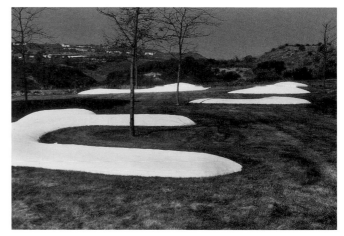

In general these shapes lend a relaxed informal atmosphere to a space.

2-166.

This design for a community xeriscape garden shows how the concept plan guides the placement of the meandering edges to create walks, walls, a dry creek, and planting areas. Note how important the forms become in defining three-dimensional space.

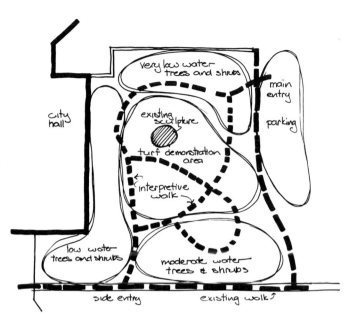

2-167. Concept plan.

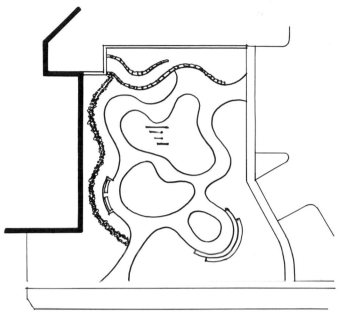

2-168. Garden form.

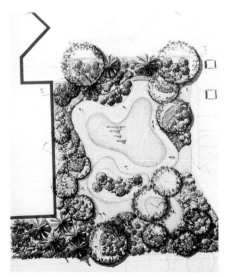

2-169. Final plan.

2-170. Completed landscape.

In developing a meander or free-form design, it is best to draw the lines freehand, fairly rapidly. Keeping fingers still, use shoulder and elbow joints. Strive for strong, smooth, flowing undulations that have no straight lines and no irregular blips or wobbles.

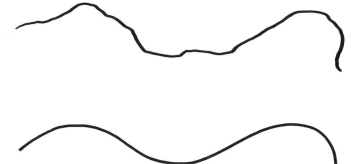

Here we see a weak meandering line with indecisive wobbles.

This shows a strong meandering line with smooth decisive curves and a fluid rhythm.

2-171.

The Free Ellipse and Scallops

If we take the ellipse as described under geometric form and discard the constraints of pure mathematical exactness, we have a more natural *free ellipse*. Form it very easily by drawing a flattened circle or oval in a loose freehand technique. These bubblelike shapes are best drawn fairly fast and with several circuits, allowing you to smooth out blips or round out flat parts on the second or third circuit.

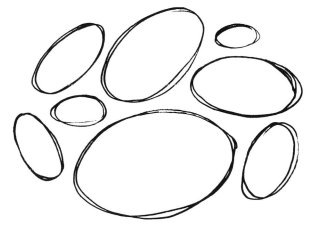

2-172.

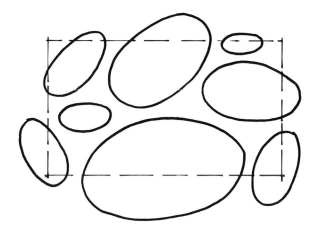

2-173.

Free-floating ellipses adapt well to the design of pedestrian walkways. The spaces and sizes can be adjusted to suit the circulation pattern.

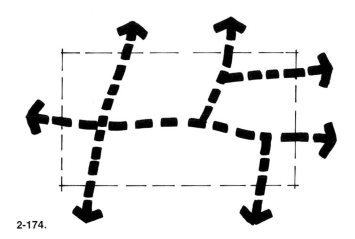

2-174.

2-175.

The outline from *touching ellipses* sets up dynamic-looking spiked forms.

2-176.

Following the outside of a ring of ellipses results in a bulging appearance.

2-177.

Following the inside of the cluster results in a sharply scalloped appearance.

2-178.

The same pointed characteristics in the silhouette of an oak leaf can be adapted to landscape materials, as shown at the end of this section.

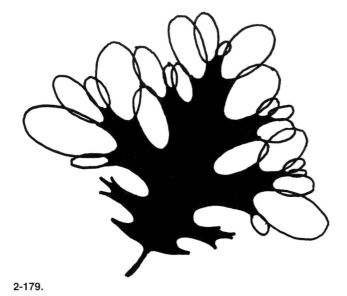

2-179.

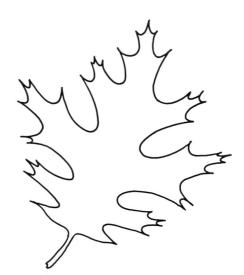

2-180.

Varying the arrangement and size of the bubbles will be necessary to meet the spatial or functional requirements of the concept plan. When forms overlap, the intersecting lines should cross at approximately 90°, or close to it, before you refine the shapes by redrawing the outline and establish the materials they represent.

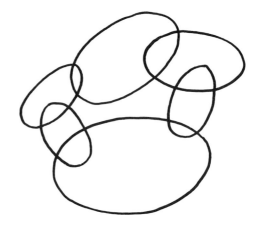

2-181.

Notice the different character that results from tracing around the outside versus around the inside of linked ellipses.

2-182.

If we take the same grouping of linked ellipses and change direction at the intersections, a series of reverse scallops results. The partial ellipses reciprocate or move back and forth to create interesting possibilities for site design.

2-183.

2-184.

This small lichen's growth pattern is a variation on the outward scallop. The ends are blunt instead of sharp and could also be drawn with more short scallops to show a form like this.

2-185.

2-186.

Look for the ovals and scallops in the following examples of designed spaces.

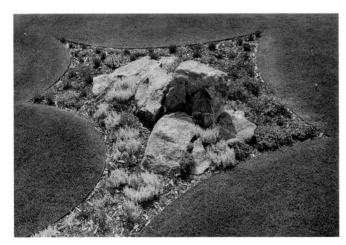

2-187.

2-188.

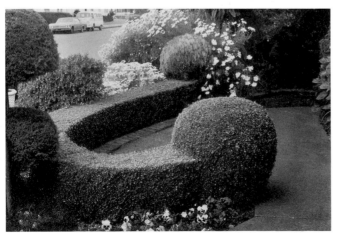

2-189.

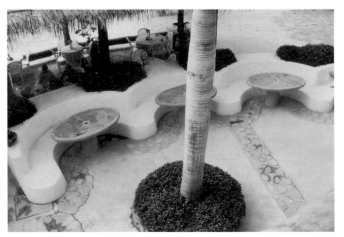

2-190.

The Free Spiral

Two major types of spirals are important to free-form development. One is the three-dimensional spiral or helix typified by the spiral staircase, where the spiral shape moves around a central axis, staying the same distance from it.

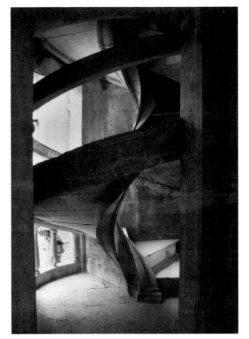

2-191.

The other is the two-dimensional spiral as found in the nautilus shell, where the spiral line moves farther and farther away from a central point as it rotates around it.

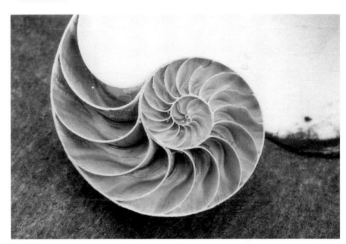

2-192.

Both types of spirals combine in some natural organisms.

2-193.

To keep the concept simple we will explore only the two-dimensional spiral.

A basic design used by the natives of New Zealand, the Maoris, is called a *koru*. A spiral stem terminates in a bulb that resembles the unfolding frond of the tree fern. It is one of several natural organisms patterned on variations of the logarithmic spiral described earlier.

2-194.

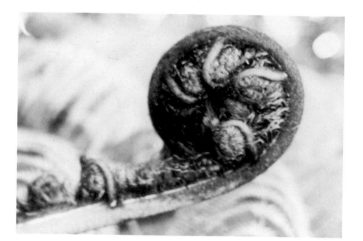

2-195.

By combining the koru in various ways the Maori painter and carver produce a variety of interesting designs (Phillips, 1960). The combinations, in turn, evoke images of other natural objects such as waves, flowers, and leaves.

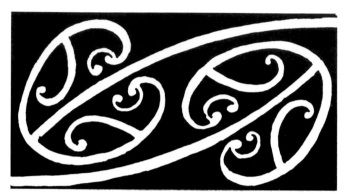

2-196.

The reverse spiral unlocks other possibilities. At any point along a spiral shape, a second spiral can begin with a rotation in the opposite direction. If the transition occurs at an angle close to 90°, a powerful connection results. Some of these shapes can look like breaking waves.

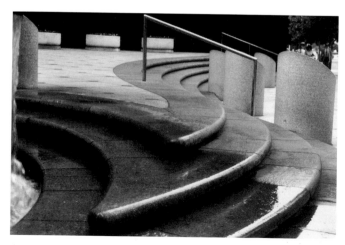

2-197.

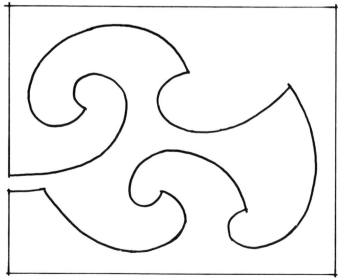

2-198.

Reverse linked spirals combine with scallops or elliptical shapes to give added freedom to form evolution.

2-199.

Loose partial spirals and ellipses link to create a hierarchy of subspaces in this small plaza design.

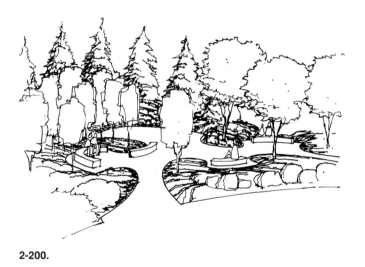

2-200.

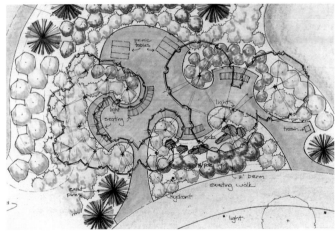

2-201.

A xeriscape demonstration garden designed by the author uses free spiral forms to articulate a stone wall and a linked spiral to form a looped walk.

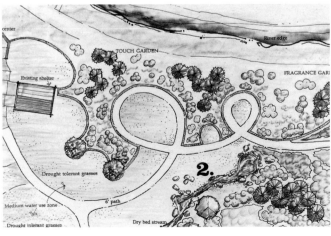

2-202.

These pictures demonstrate other applications of the spiral in developing landscape form.

2-203. Paving pattern (Del Mar, California).

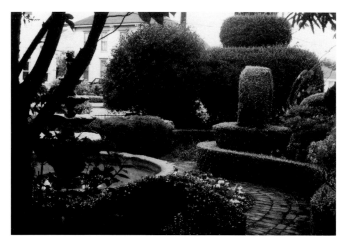

2-204. Topiary garden (Oregon).

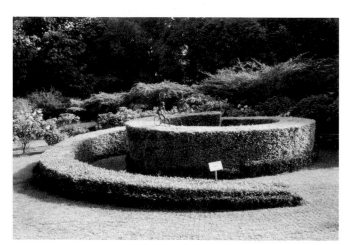

2-205. Singapore Botanic Gardens.

2-206. Fountain (Slovenia).

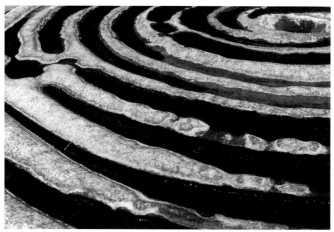

2-207.

The Irregular Polygon

Nature contains a multitude of straight-line ordering systems.

Fracture lines in granite boulders show the essential characteristics of a naturalistic irregular line. Its length and change of direction appear random. This loose, random quality makes it different from geometric angular patterns.

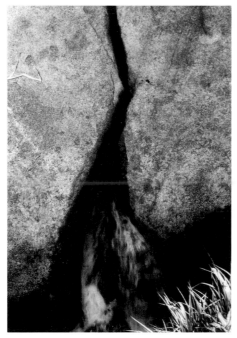

2-208.

2-209.

When applying such irregular or random design, use many different line lengths and vary the angles within the guidelines below.

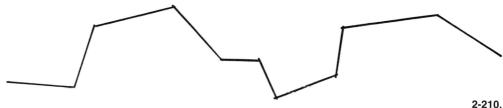

2-210.

Use obtuse angles between 100° and 170°.

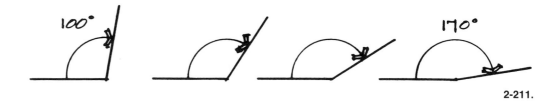

2-211.

Use reflex angles between 190° and 260°.

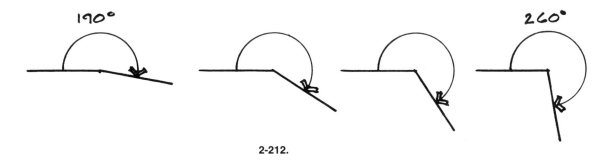

2-212.

Avoid too many angles closer than 10° to a right angle or a straight line, and too many parallel sides. Repeated use of parallelism and 90° angles returns the theme to the more rigid character of the rectangular and angular geometric forms discussed earlier.

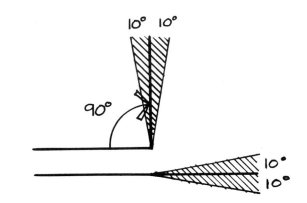

2-213.

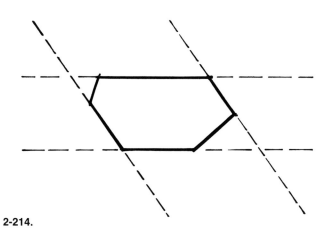

2-214.

Building acute angles into design should be avoided. As with the other angular themes, acute angles can give rise to structures difficult to build, pavement that may crack, confined unusable spaces, and landscapes that are difficult to maintain or irrigate.

2-215.

The *irregular polygon* arises here in the erosion pattern of coastal sandstone. Note the apparent randomness inherent in the line length, the angular change of direction, and the size of the polygons.

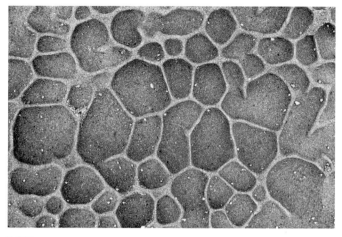

2-216.

2-217.

The irregular polygon appears in its application to landscape materials in these irregular pool designs.

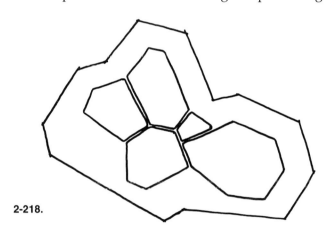

2-218.

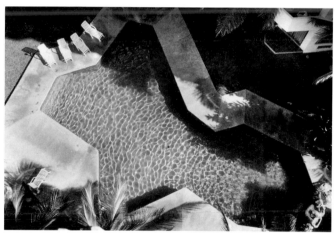

2-219.

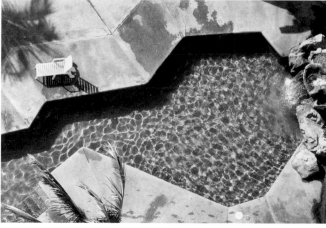

2-220.

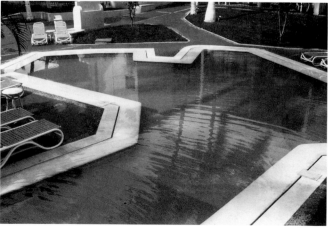

2-221.

Organization of polygons in a lineal context produces semiformal walkways or stepping stones.

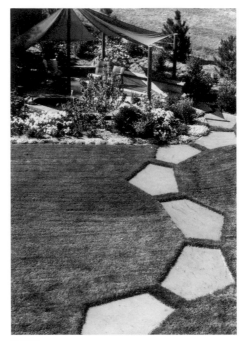

2-222.

In this aerial view of the Embarcadero Plaza in San Francisco, California, the use of irregular angles appropriately expresses the feeling of brokenness or earthquake damage, one of the original conceptual themes when the plaza was being designed.

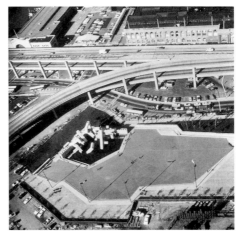

2-223.

In Sausalito, California a small bayside plaza effectively uses subtle level changes so that the tidal fluctuations sequentially fill and empty irregular polygonal terraces.

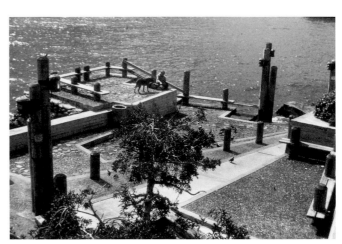

2-224.

This streamside plaza in Beaver Creek, Colorado incorporates irregular shaped platforms which step down into the water.

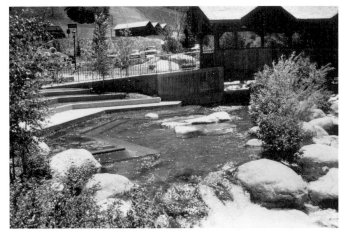

2-225.

A more severe pushing of the vertical dimension, again using irregular angles and planes, produces a powerful drama of spatial experience in this urban water plaza in Texas.

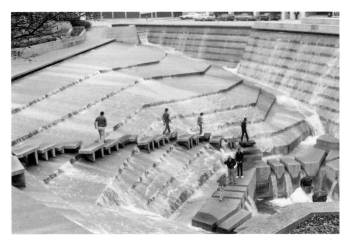

2-226.

Though caution is in order concerning acute angles in man-made structures, nature includes acute angles in irregular polygons frequently:

the plates of tree bark;

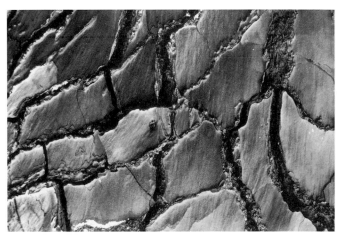

2-227.

the lines in drying mud.

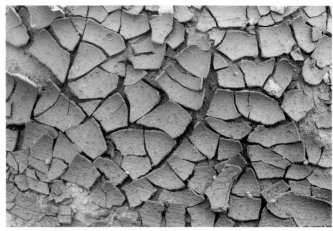

2-228.

These forms often appear as informal ground plane patterns in designed landscape spaces.

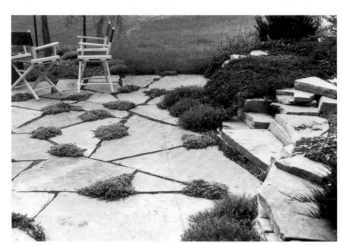

2-229.

The Organic Edge

A simple line allowed its change of direction in total random expression produces a shape so irregular that none of the previous shapes (meander, loose ellipse, spiral, or polygon) seem to apply. Its "organic" quality can best be found by looking at examples from nature.

Lichen growing on rock has a well-defined yet extremely irregular outer edge with unpredictable bends that double back on themselves. Such a high degree of complexity and detail is characteristic of the organic edge.

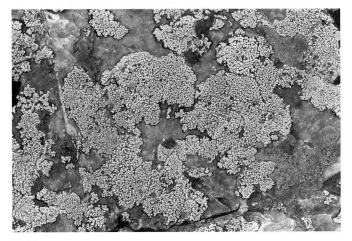

2-230.

2-231.

Soft, irregular patterns often arise in natural plant communities. Although diverse in form, they possess a sense of visual order resulting from the plants' responses to ecological changes, those unpreventable factors such as water regime, soils, microclimates, occasional fires, or animal habits.

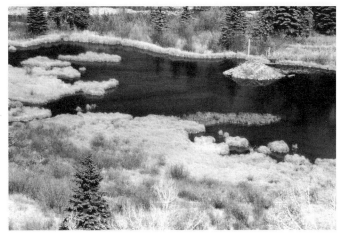

2-232.

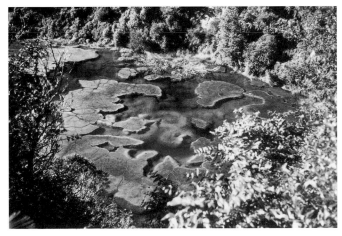

2-233.

2-234.

The organic theme may be expressed as a soft random edge

2-235.

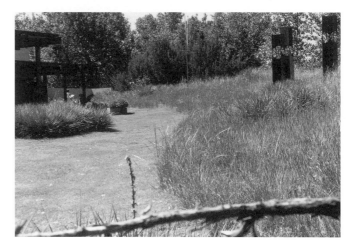

2-236.

or a hard random edge such as might be seen in a broken rock.

2-237.

Look for these characteristics built into the following landscapes. Although natural materials such as uncut rock, soil, water, and vegetation achieve organic form easily, man-made moldable materials like concrete, fiberglass, or plastics can also express organic qualities. This higher level of complexity brings an intricacy of movement to a design, adding interest and engaging the viewer's attention.

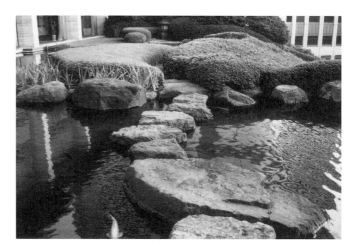

2-238.

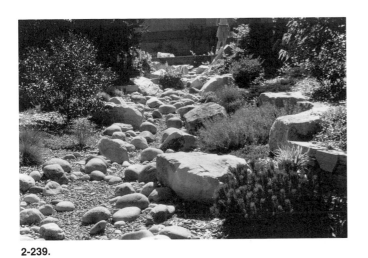

2-239.

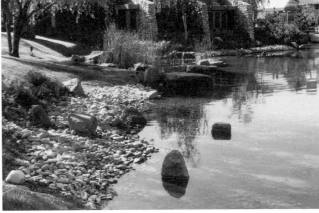

2-240.

2-241.

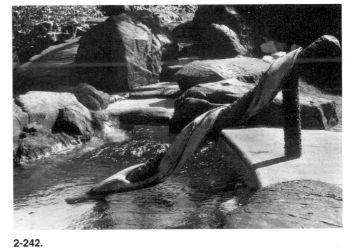

2-242.

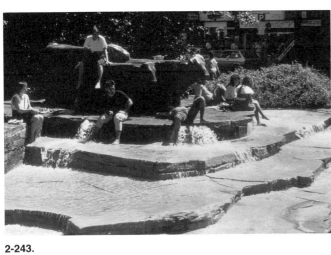

2-243.

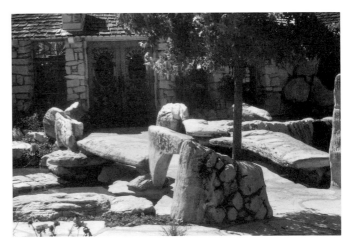

2-244.

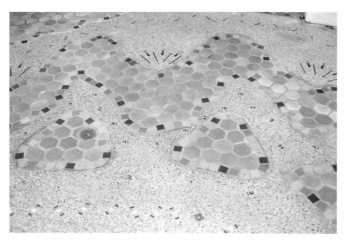

2-245.

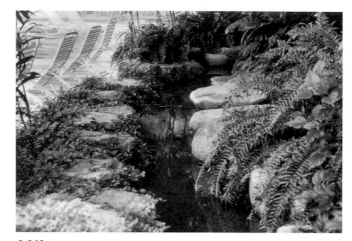

2-246.

Clustering and Fragmentation

An interesting duality further characterizes natural-istic form. It tends at once to unite and to disintegrate. On the one hand, elements cluster or draw together, as if magnetized, into irregular groups. On the other, elements disperse or fragment into irregularly spaced segments.

Many such forms are explored here as derivations and interpretations of specific images of natural objects.

Landscape architects use clustering and fragmentation in planting design to create informal masses of the same plant or drifts of plant groups that intertwine and wrap around each other.

2-247.

2-248.

2-249.

The key to successful natural clusters is to apply randomness and irregularity within the limit of a unifying whole. For example, rock groupings around a pond can be varied by size, spacing, and shape. Some should be larger than others. Spacing and shape should vary with some projecting out into the water and others stepping up the bank. Some may show a deep profile while others may appear flat. Unity results from choosing rocks that all have the same general color, texture, form, and orientation.

2-250. Natural cluster.

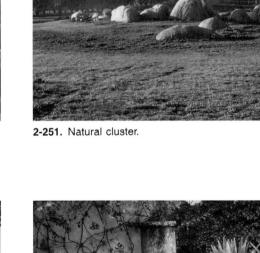

2-251. Natural cluster.

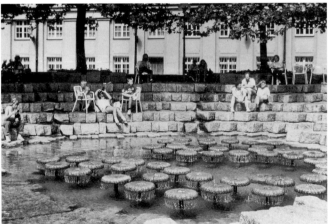

2-252. Designed cluster.

2-253. Designed cluster.

There are also examples of fragmentation that convey a feeling of breaking apart. Inherent in this idea is the concept of gradual transition from very tightly packed elements to very loosely spaced elements.

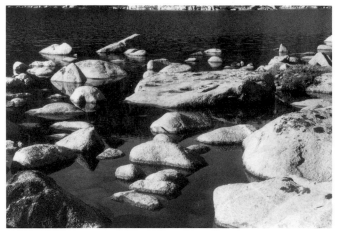

2-254. Natural fragmentation.

2-255. Natural fragmentation.

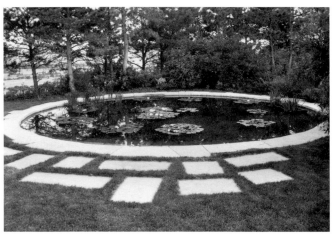

2-256. Designed fragmentation.

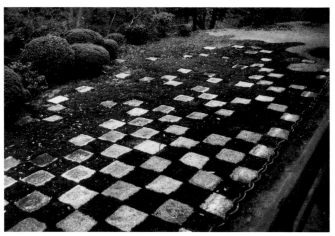

2-257. Designed fragmentation.

Both clusters and fragmentation may be useful in the landscape where the designer wants to achieve gradual transition from hardscape (for example, paving) to softscape (for example, grass) on the ground plane;

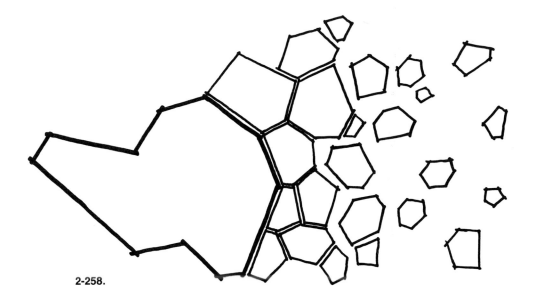

2-258.

or to create a sense of blending of one plant massing into another. In each case clusters would fragment or disperse into the other at a loose interface.

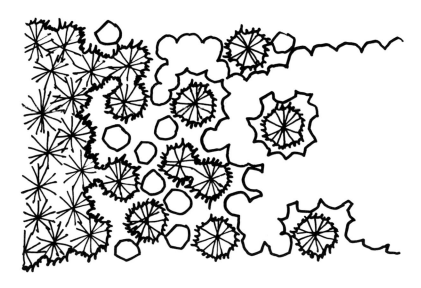

2-259.

INTEGRATION OF FORM

A strong sense of design unity evolves from the manipulation of only one of the many possible development themes. Repeating the same generic shapes, line character, and angles while varying size or direction avoids monotony. Very often, however, to combine two or more contrasting forms is desirable. Perhaps several subthemes exist in the conceptual design; perhaps a change of materials indicates a need for change of form; perhaps the designer wants contrast to add interest. Regardless of the reason, care should be taken to create a harmonious integration. The most useful principle of integration is to use 90° connections. When circular forms are integrated within rectangular or angular forms, the 90° connection becomes automatic when radial or tangent lines are recognized. All lines then have a direct relationship to the circle center and therefore a strong connection to each other. The top half of Figure 2-260 shows several possibilities.

Ninety degree connections can also be a viable way to connect meanders to straight lines or straight lines to other naturalistic shapes. Parallel alignment is another transition from one form to another. Obtuse angle connections, necessary in some cases, tend to be less direct. Acute angle connections should be used very sparingly since they usually result in awkward, forced relationships between contrasting forms.

Harmonious transitions can also be achieved with buffer space and graded change. Buffer space simply means leaving enough uncluttered visual distance between contrasting shapes to cushion visually any potential conflict.

Graded change has a similar effect except that here the designer provides several intermediate visual forms to reveal a gradual transition between one and the other. A transition from a meandering curve to a straight-line form is shown on the right side of Figure 2-260.

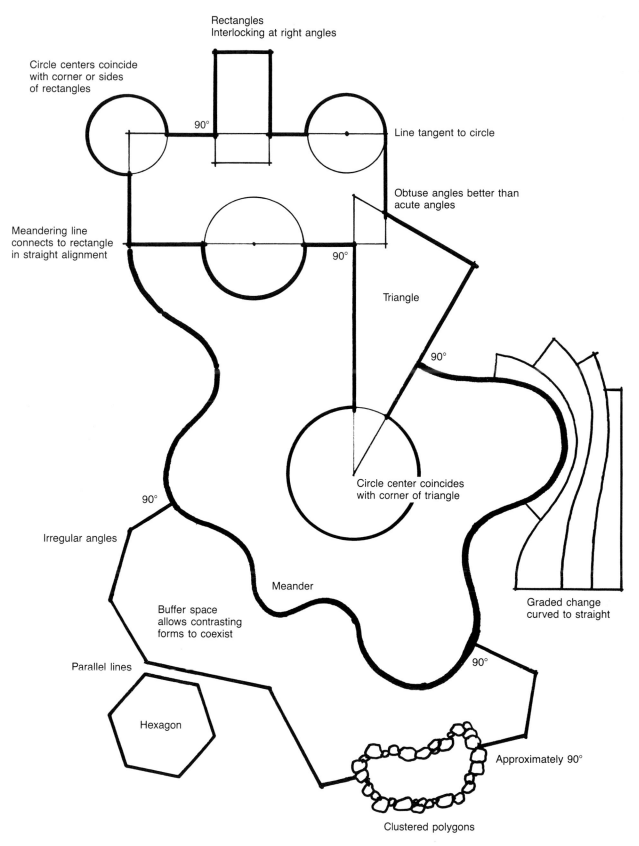

Rectangles
Interlocking at right angles

Circle centers coincide
with corner or sides
of rectangles

90°

Line tangent to circle

Obtuse angles better than
acute angles

Meandering line
connects to rectangle
in straight alignment

90°

Triangle

90°

Circle center coincides
with corner of triangle

90°

Irregular angles

Graded change
curved to straight

Meander

Buffer space
allows contrasting
forms to coexist

Parallel lines

90°

Hexagon

Approximately 90°

Clustered polygons

2-260. Integration of form.

The Roman arch shows a very clear and simple transition from a circular form to rectangular forms. The arch stone shapes form radial lines that intersect the corners of bricks at obtuse angles.

Each of the illustrations that follow contain two or more contrasting forms. Look for 90° connections, buffer space, and graded change.

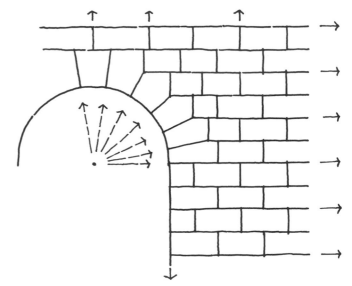

2-261.

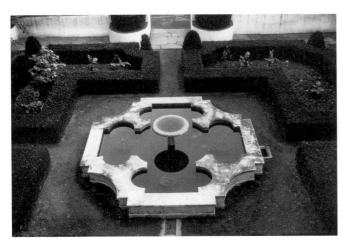

2-262.

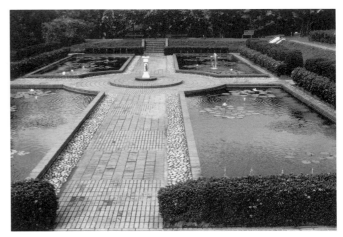

2-263.

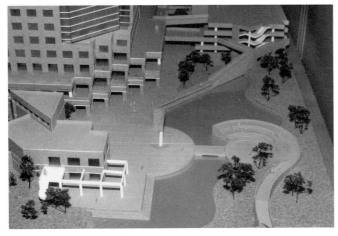

2-264.

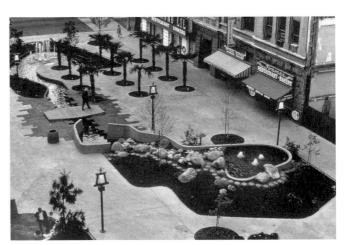

2-265.

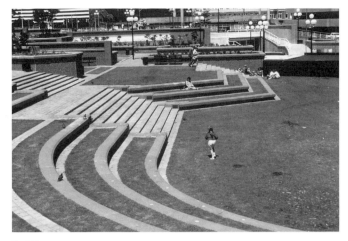

2-266.

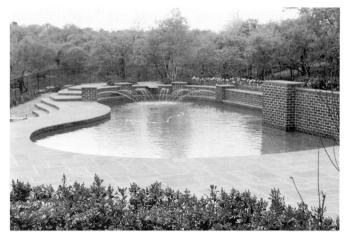

2-267.

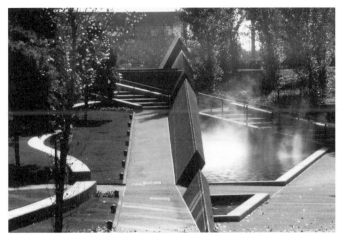

2-268.

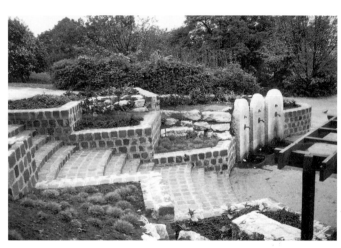

2-269.

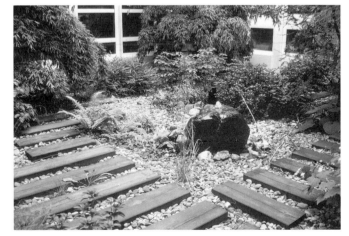

2-270.

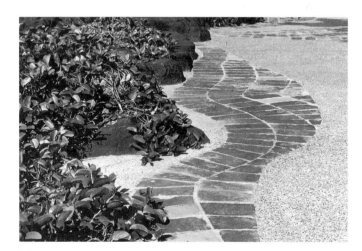

2-271.

REFERENCES

Critchlow, K. 1970. *Order in Space*. New York: Viking Press.

Hoff, Benjamin, 1981. *The Way to Life*. New York: Weatherhill, Inc.

Phillips, W. J. 1960. *Maori Rafter and Taniko Designs*. Wellington, New Zealand: Wingfield Press.

The discussion of form development in the previous chapters dealt with systematic procedures or *techniques of organization*. Although these forms are very useful, a designer needs to combine them with *principles of organization* in order to create well-designed outdoor spaces. Basics such as unity and harmony have been referred to already since there is often a relationship between a particular technique and the underlying principle. Application of these principles should begin during the early stages of concept planning and continue through final stages of design refinement.

The observer's grasp and enjoyment of the surrounding world depend on two complementary principles of perception: a need for stimulation through novelty and a need for familiarity. The first is a response to change; the second, a response to constancy. Such responses involve a paradox. Perception demands variety and new information and at the same time seeks security in regularity or repetition. A familiar pattern that contains somewhere within it an unexpected change will likely create aesthetic satisfaction. Design solutions are seldom absolutely right or wrong, all good or all bad. Beauty is perceived in degrees and is also relative to the person's previous experience. Given such variable human response, however, it is still safe to say that a recurring visual principle or organization is *unity and harmony with interest*.

Unity is the coalescing of the separate design elements to allow an easy overall grasp and perception of the whole composition as one. When the forces of nature begin to split a rock apart, the fragments may be very different in size and shape but they are situated within the bounds of the one original rock. Unity is this quality of oneness and cohesion, achieved by arranging a variety of landscape elements within an overall organizational theme. Thus, using the thematic techniques suggested in Chapter 2 establishes the framework of a unified design.

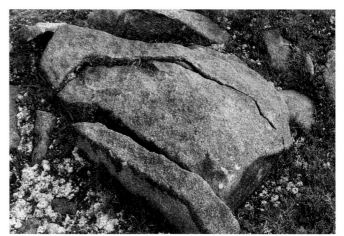

3-1.

Additional unifying techniques include *repetition* of line, form, texture, or color—particularly effective when used in conjunction with *grouping* similar elements into tight clusters of connected lineal arrangements. Examples include:

rectangular paving repeated throughout the space;

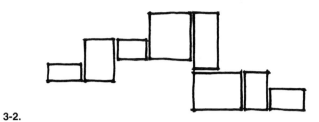

3-2.

use of a flowing body of water as a unifying thread interspersed with repeated clusters of boulders;

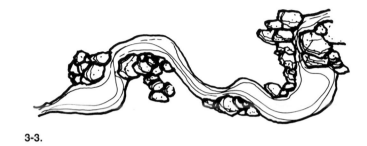

3-3.

organizing plants into strong well-defined groups of similar species.

3-4.

Without some measure of unity a design will be in chaotic disarray such as in this botanical jumble of plants,

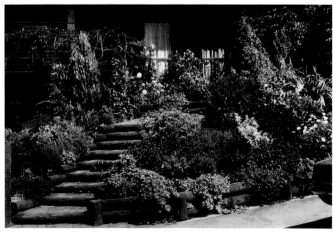

3-5.

or this large variety of rocks strewn randomly over a gravel plane, or haphazardly dumped in a pile.

Why wouldn't a pile of dumped rocks work as an effective design? After all, it does have some sense of unity through clustering! The answer lies partially in the meaningless variety of rocks and in the lack of harmony. Perhaps designers can take comfort that nature is never random, for the same reason that Einstein could "never believe that God plays dice with the world."

Harmony is a state of accord among elements and with their surroundings. In contrast to unity, harmony has to do with the relationship between elements as opposed to the overall picture. Elements that blend, mesh, or fit with each other are harmonious. Elements that seem to violate each other's integrity or their settings are disharmonious. Some techniques for achieving harmony are shown beginning on page 78 in the section on integration of form. The key ideas are to maintain smooth transitions, strong connections, and adequate buffers between diverse elements.

Authenticity and *functional value* improve harmony. Solving landscape problems by using natural materials executed with sincerity of purpose tends to be more harmonious than by using artificial products with no sense of artistry or function. A general guideline is to avoid solutions that appear incongruous, awkward, or weak.

At the risk of promoting a controversy on the difference between what might be considered poor design and poor taste, the following examples are offered as lacking in harmony:

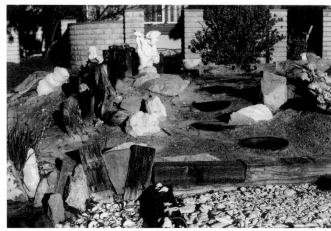

3-6.

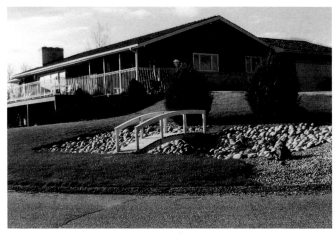

3-7.

a small bridge in the lawn going nowhere in particular and crossing nothing of significance is incongruous with its surroundings;

weathered stumps placed carefully in a row;

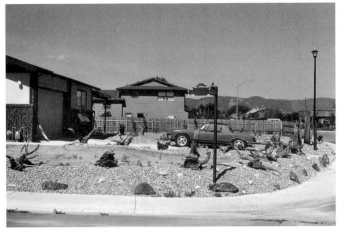

3-8.

ducks, deer, frogs, and swans, all vying for attention, are weak and awkward filling of space.

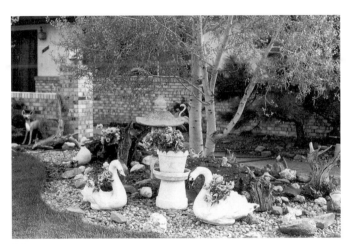

3-9.

On the other hand, twenty flamingoes in a group could create a striking and harmonious impact.

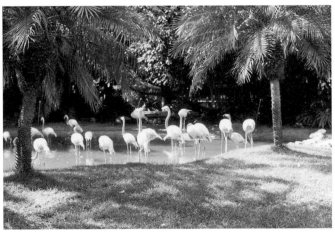

3-10.

Harmonious compositions are visually comfortable.

3-11. Harmonious composition.

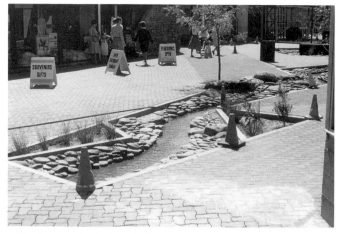

3-12. Composition lacking in harmony.

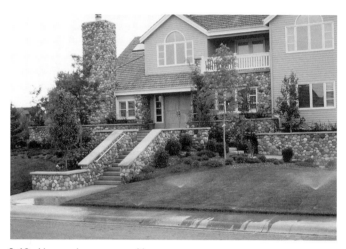

3-13. Harmonious composition.

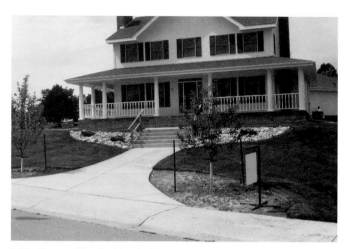

3-14. Composition lacking in harmony.

There is, however, validity to compositions that are deliberately disconcerting and filled with tension. Chapter 5 offers some applications where the controlled use of discord and deception add an exciting dimension to outdoor space.

Interest is the feeling of curiosity, fascination, or absorption. It is not a basic principle of organization but an essential aspect of aesthetic satisfaction and therefore of successful design. Interest is achieved by introducing variety in shapes, sizes, textures, and colors; and changes in direction, movement, sound, or light quality. It can be heightened further by the use of unusual or unique elements as well as patterns of organization that foster discovery and surprise.

The graphic sequence below has been deliberately oversimplified to show the differences and interdependence of unity, harmony, and interest.

Chaos — The composition lacks unity, harmony, or interest. The arrangement is chaotic with weak relationships among the squares.

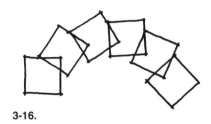

3-15.

Unity — The composition is unified by the curved organization and somewhat by the repetition of the squares. But it lacks harmony because of the awkward connections.

3-16.

Harmony — The composition contains harmonious relationships between the squares. All the squares are in parallel relationships, but as a whole it lacks a powerful unity or sense of cohesion among the units.

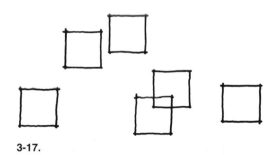

3-17.

Unity and harmony — The composition is now unified through organization within a rectangle and has harmonious relationships, but like the previous compositions it lacks interest.

3-18.

Unity and harmony with interest — Here the composition is unified within an "S" arrangement. All edges are aligned in a harmonious parallel relationship. The size variation of the squares adds interest.

3-19.

Several other principles of organization have value applied separately or in support of the triad above.

Simplicity is the result of reducing or eliminating nonessentials. It is an economy of line, form, texture, and color. Therefore, it is a basic form of order helping to bring clarity and purpose to a design. Taken to the extreme, however, simplicity can result in monotony.

3-20.

Diversity is simplicity's opposite. Taken to the extreme, it can result in chaos unless restrained by a powerful unifying theme. No precise formulas can be given, but it is important to find a comfortable balance between simplicity and diversity, a balance tempered by the site and the program.

The compositions shown here have been reduced to the essentials with just enough variety to maintain interest.

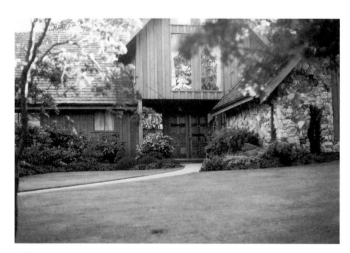

3-21.

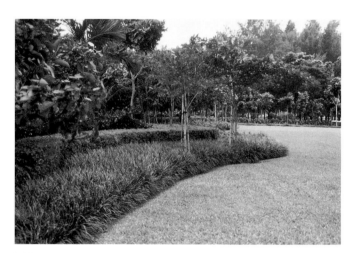

3-22.

Emphasis or dominance is the importance or significance imparted to an element in the landscape. It requires an organization that focuses on the attraction, influence, or power of one element or zone over what surrounds it. Limited use of emphasis provides resting places for the eye and helps in orientation. The overall design becomes more pleasing when a person can easily determine what is most important.

Emphasis is achieved primarily through the decisive use of *contrast*. The element may be a large mass amidst much smaller masses, a bold shape protruding against an amorphous background, a bright color within dull ones, dramatic, coarse textures surrounded by fine, receding textures, or the use of focused sound as from a waterfall.

3-23.

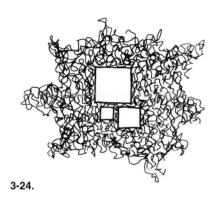

3-24.

3-26.

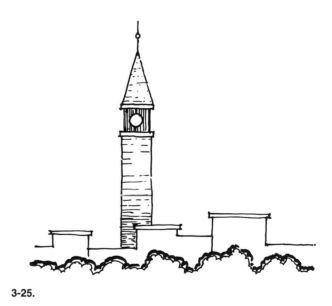

3-25.

3-27.

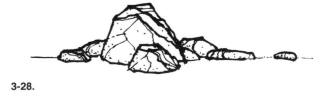

3-28.

Emphasis is also achieved by the introduction of an unusual or *unique element*, as shown in these scenes.

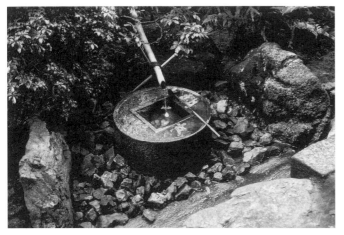

3-29.

3-30.

3-31.

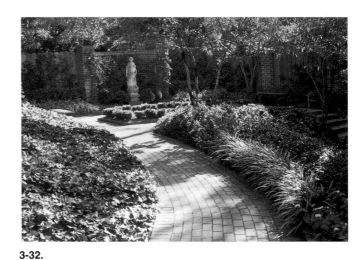

3-32.

Enframement and *focalization* complement the principle of emphasis. They are techniques that depend on a supporting peripheral landscape. Focalization occurs when the surrounding elements are structured in a manner that encourages a viewer to look at a particular scene. However, care should be taken to make sure that the focal zone is worthy of prolonged attention.

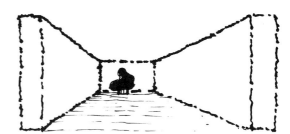

3-33.

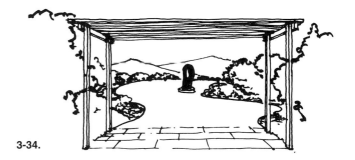

3-34.

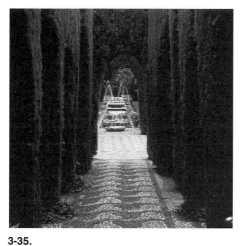

3-35.

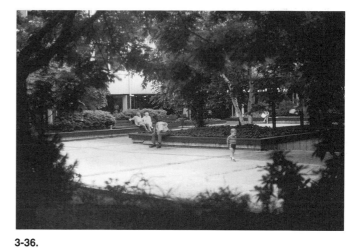

3-36.

When the principle of emphasis is applied to a lineal landscape clement or to a patterned surface, rhythm results. *Rhythm* is regular repeated emphasis. Breaks, variations, and pulses can bring an exciting sense of movement to the landscape.

3-37.

3-38.

Balance is a perceived state of equilibrium. It implies stability and is used to evoke a sense of peace and security. In landscape design it is more often applied from a static point of view, such as from a balcony, an entry point, or a resting area. Certain parts of a scene catch our attention more than others because of contrast or association with the unique and unusual. The mind is most at ease when various attractions are balanced about an imaginary fulcrum. In landscape composition this balance usually means equilibrium of attention around a vertical axis in a perspective.

A formal balance is geometric, symmetrical, and is characterized by repetition of similar elements on either side of a central axis. It is static and predictable, creating a sense of stateliness, dignity, and conquest of nature.

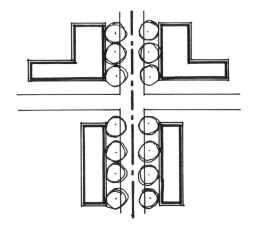

3-39.

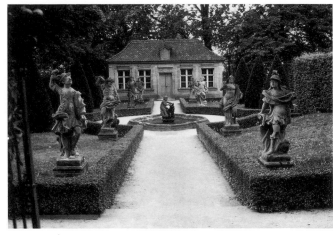

3-40.

An informal balance is nongeometric and asymmetrical. It is often fluid, dynamic, and naturalistic, creating a sense of curiosity and movement.

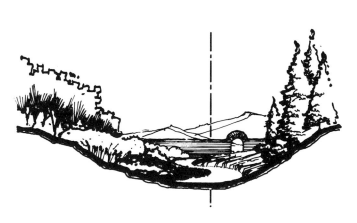

3-41.

3-42.

Scale and proportion refer to relative comparison of heights, lengths, areas, masses, and volumes. Comparisons may be between one element and another or between an element and the space it occupies. Most importantly, we tend to size up what we see in relation to the size of our own bodies.

A "micro" scale refers to miniaturization, in which the size of objects or spaces is close to or smaller than our own size.

3-43.

A "grand" scale refers to space or objects in multiples of our own size too large to comprehend easily. The grand can evoke emotions of wonderment and amazement.

3-44.

Somewhere in between is the area of human scale in which spaces and objects can be easily recognized as ratios of the human body. Although difficult to quantify exactly, exterior spaces seem to have a comfortable human scale when the ground plane dimensions are between two and twenty times the height of the human body and the vertical plane or walls are one third to one half as high as the ground plane is wide.

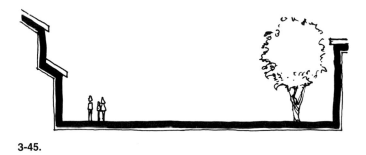

3-45.

Within this wide range of human scale it is often desirable to provide a *hierarchy* of spatial experience: One space might be suitable for larger groups and another for small groups. Related to spatial hierarchy is the notion that one space would be clearly dominant. But the principles of balance and scale are seldom considered simply in terms of good or bad, essential or unnecessary. They are principles of organization that can be manipulated by the designer to evoke various emotional responses.

Sequence has to do with movement. Static pictorial views from a deck, from a seat, or through an opening can be important interludes. We most often experience outdoor space, however, by moving through it. Connected series of spaces and events become a sequence. Water flowing along a mountain stream moves from a gentle quiet flow to a waterfall, drops into a deep pool, outlets to fast-running rapids, and settles into a lake. Likewise, in outdoor spaces the designer should consider the direction, speed, and mode of movement. A well-executed sequence should have a point of beginning or a gateway that indicates the principal approach. A variety of spaces and focal experiences may follow. They should be linked to form a logical progression that ends with a climactic feeling of arrival. The arrival should provide a dominant interlude and exhibit a strong sense of place, of being at the heart of things. It can also be a threshold, a gateway into another sequence. Indeed, it is legitimate to have multiple paths and sequences.

Many of the previously mentioned principles (emphasis, focalization, rhythm, balance, and scale) can help to structure the sequence. Sequences that involve discovery are most effective. It is often best not to reveal everything at once. A corner may hide a connecting room or focal zone; a gap may reveal a glimpse beyond. The excitement of exploration enhances the experience. Note the sense of mystery in the examples of built landscapes shown here.

As your design evolves into physical form, ask yourself these useful questions.

Is the composition designed so that the different parts can be seen as a single strong picture?

Do the elements blend well with each other and their surroundings?

Do I have adequate variety, limited emphases, and discovery opportunities?

Is everything in this design absolutely necessary? Have I eliminated all meaningless forms, irrelevant materials, and redundant objects?

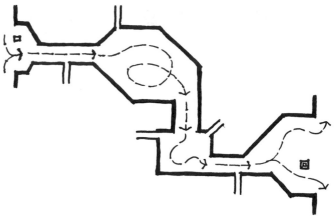

3-46.

3-47.

3-48.

The six projects that follow demonstrate the evolution of a design from concept to form. Each of these is a real site and involves the integration of specific client needs or concerns. The client and site-driven programmatic design criteria are not discussed in detail. They precede concept plan development and to a certain extent are revealed in the *concept plan* itself and the design interpretation. Each project is analyzed in three or four sequential graphics that would normally evolve as overlays. The *theme composition diagram* shows the underlying themes that will be used to structure much of the design. As discussed in earlier chapters, the design takes shape by blending spatial messages from both the concept plan and the theme composition diagram as the designer reads back and forth between each layer. Throughout the evolution of form, the designer must also consider the diverse opportunities inherent in the basic principles of design. For each project these opportunities are listed as a *design interpretation*. First the design themes are listed; relevant principles such as dominance, scale, contrast, unity, and spatial characteristics are then interpreted. A *form evolution diagram*, offered for some of the case studies, shows an intermediate step between the theme composition diagram and the *final plan*. Photographs of the completed landscape show spatial characteristics, color themes, textural qualities, and other design images not readily evident from a plan view drawing.

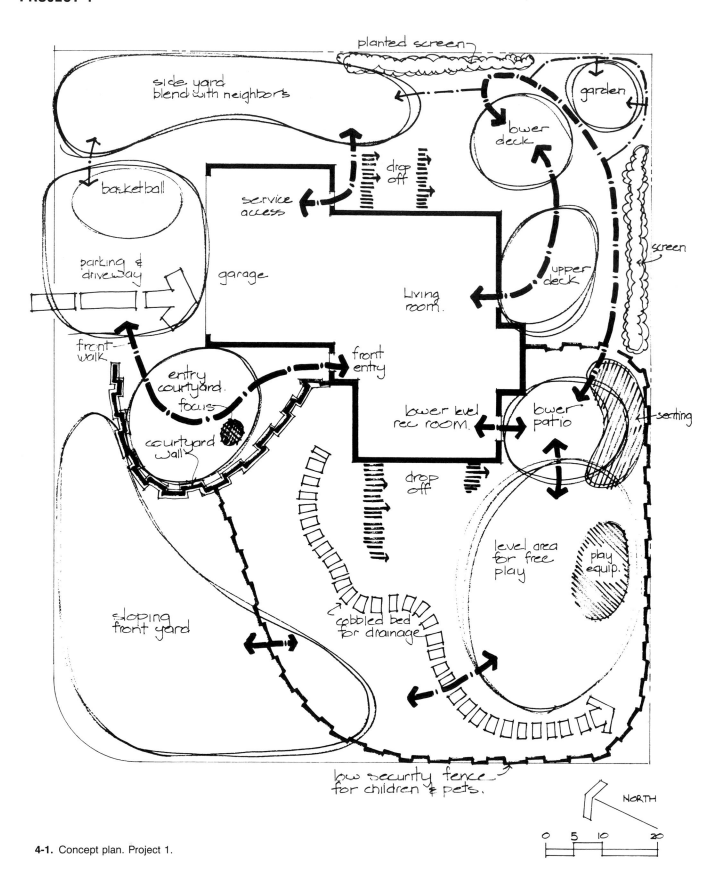

planted screen

side yard
blend with neighbors

garden

lower
deck

drop
off

service
access

upper
deck

screen

basketball

parking &
driveway

garage

Living
room.

front
walk

entry
courtyard.
focus

front
entry

lower level
rec room.

lower
patio

seating

courtyard
wall

drop
off

level area
for free
play

play
equip.

sloping
front yard

cobbled bed
for drainage

low security fence.
for children & pets.

NORTH

0 5 10 20

4-1. Concept plan. Project 1.

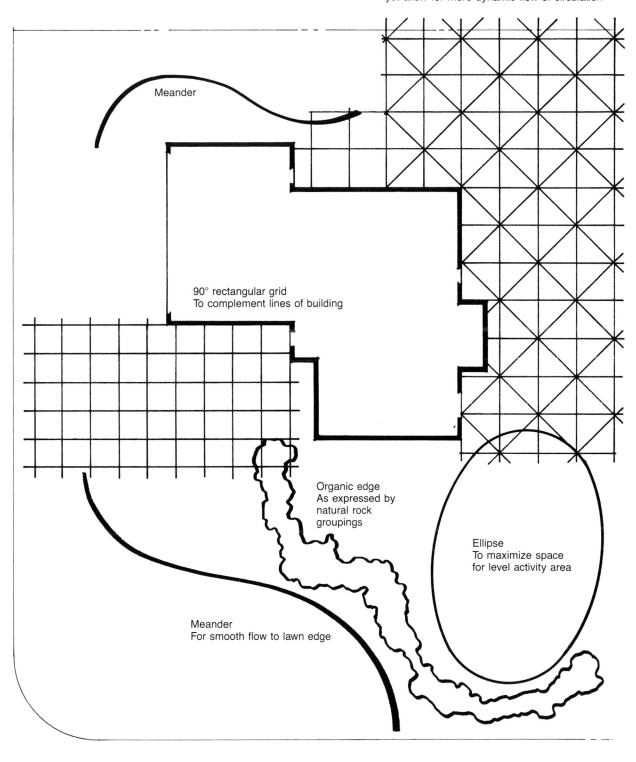

45°/90° angular grid
To make positive connections with building
yet allow for more dynamic flow of circulation

Meander

90° rectangular grid
To complement lines of building

Organic edge
As expressed by
natural rock
groupings

Ellipse
To maximize space
for level activity area

Meander
For smooth flow to lawn edge

4-2. Theme composition diagram. Project 1.

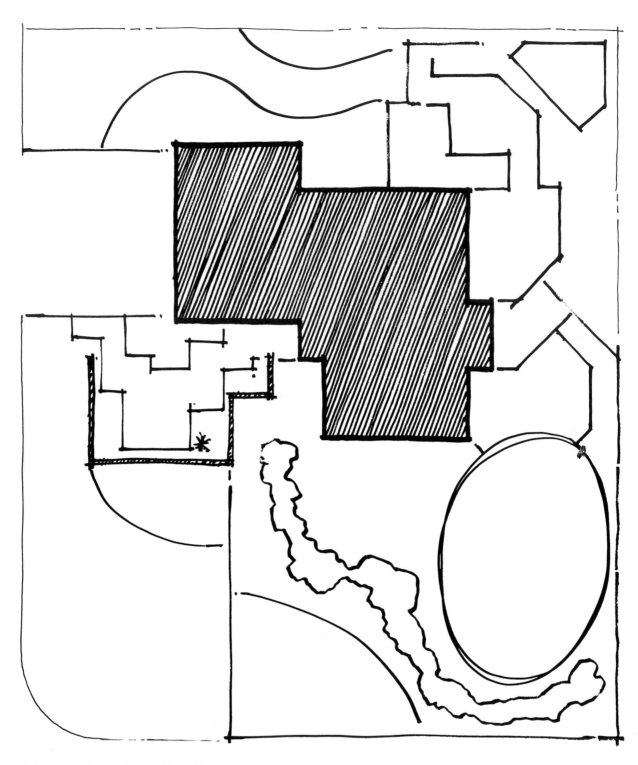

4-3. Form evolution diagram. Project 1.

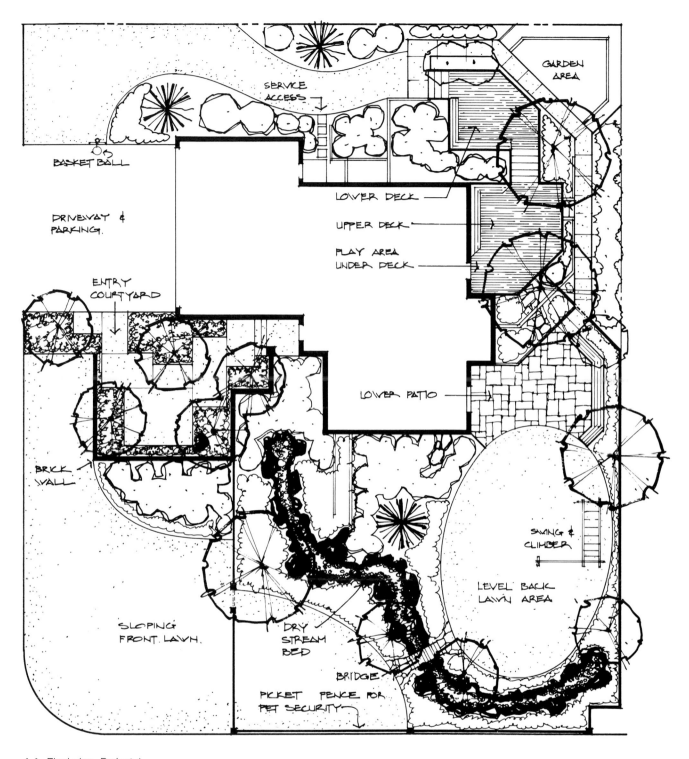

BASKET BALL

DRIVEWAY &
PARKING.

ENTRY
COURTYARD

BRICK
WALL

SLOPING
FRONT LAWN.

SERVICE
ACCESS

GARDEN
AREA

LOWER DECK

UPPER DECK

PLAY AREA
UNDER DECK

LOWER PATIO

SWING &
CLIMBER

LEVEL BACK
LAWN AREA

DRY
STREAM
BED

BRIDGE

PICKET FENCE FOR
PET SECURITY

4-4. Final plan. Project 1.

NORTH

0 5 10 20

PROJECT 1. DESIGN INTERPRETATION

Main Objectives

To provide a variety of usable spaces

To take advantage of sloping lot for views and level changes

To ensure on at least part of the site a secure boundary for child and pet safety

To emphasize built materials and colors that harmonize with the building

Structuring Themes

The 90° rectangular grid (entry courtyard)

The 45°/90° angular grid (rear decks and patio)

The ellipse (backyard lawn)

The organic edge (dry creek bed)

The meander (front lawn edging)

Principals of Design

Dominance: Redwood decks take up most of this project's backyard. Sculpture to serve as focus in entry courtyard.

Scale: Human scale. Spaces designed for small groups of two to eight people.

Contrasts: Informal shape of natural rock streambed contrasts with formal lines of brick and timber structures. Light-dark color contrasts between pillars and fence pickets.

Interest: Plantings for seasonal interest. Variety of outward views from upper levels to closer inward views from lower levels.

Unity: Deck system unified within repeating angular forms. Front entry unified with repetition of rectangles. Diverse forms in backyard unified by perimeter fence which repeats the colors and materials of the building.

Harmony: Strong direct connections between angles of patio and curves of the ellipse. Planted buffer space between straight-line, organic, and curved forms.

Spatial characteristics: Hierarchy of size and orientation of decks. Sequenced variety of level changes and direction changes in the transition from upper-level decks to lower patio. Front entry narrow-wide-narrow sequence combined with sense of enclosure from the brick walls.

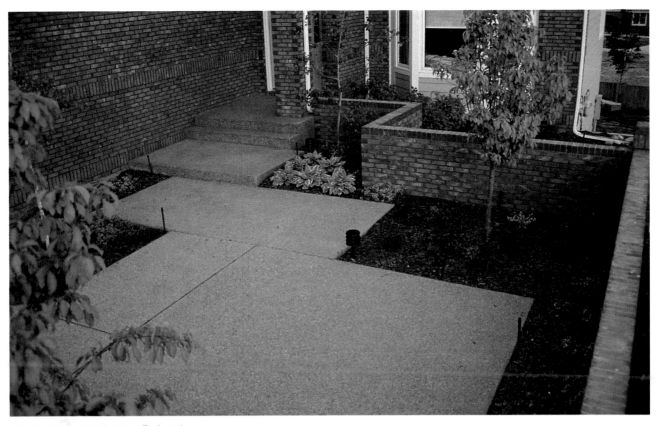

4-5. Completed landscape. Project 1.

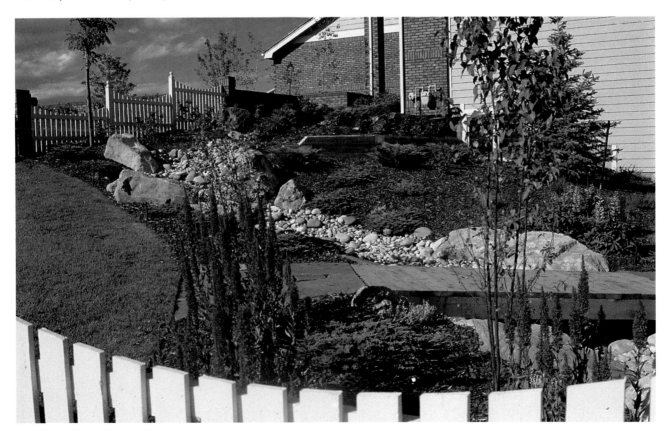

4-6. Completed landscape. Project 1.

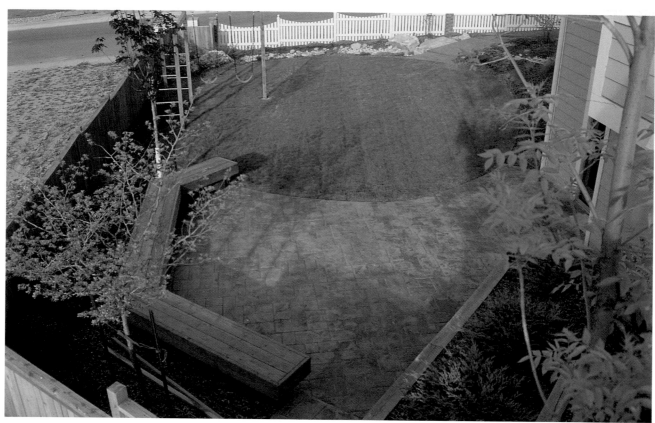

4-7. Completed landscape. Project 1.

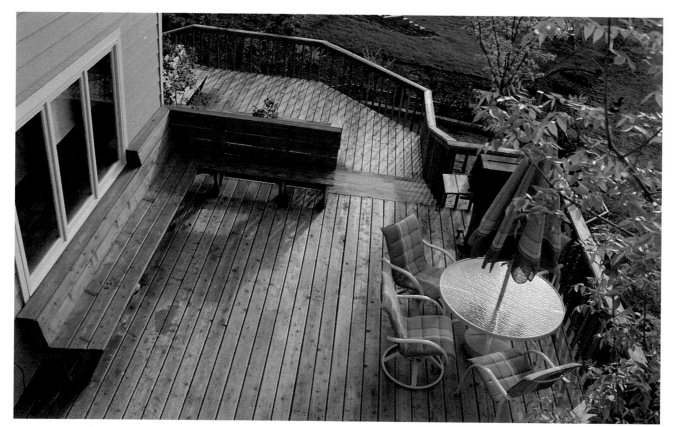

4-8. Completed landscape. Project 1.

PROJECT 2

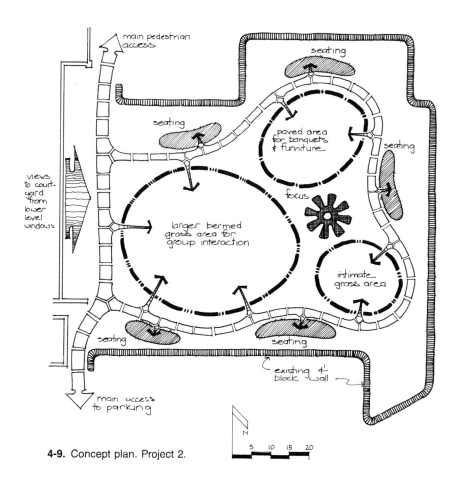

4-9. Concept plan. Project 2.

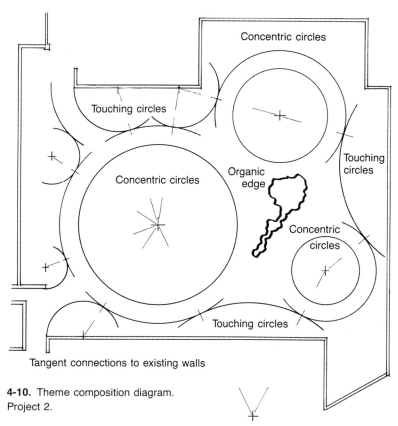

4-10. Theme composition diagram.
Project 2.

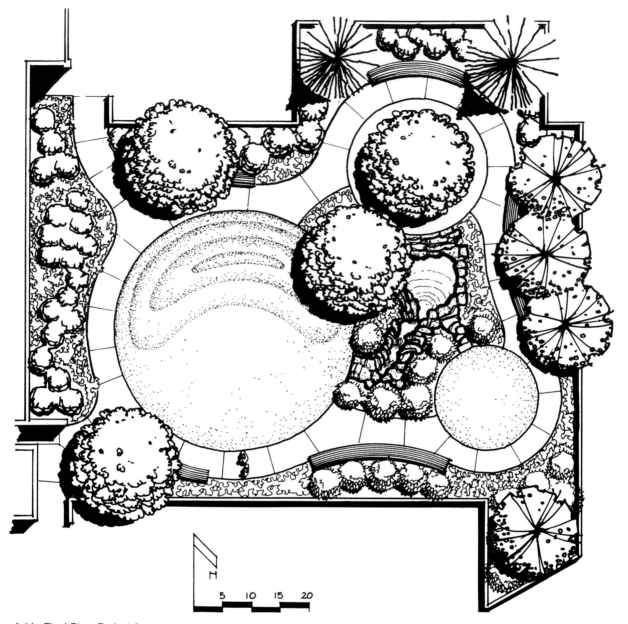

4-11. Final Plan. Project 2.

PROJECT 2. DESIGN INTERPRETATION

Main Objectives

To provide a comfortable environment for employes to relax outside during breaks

To allow space for occasional formal outdoor meetings and celebrations

To provide an interesting aerial view from adjacent high-rise balconies and windows

To utilize the existing depression from the abandoned swimming pool

Structuring Themes

Circular forms as the primary theme

The organic edge as a secondary theme

Principles of Design

Dominance: Recirculating stream and pond as the major focal element.

Scale: Human scale but large enough to accommodate larger groups of 20 or 30 people.

Contrasts: Circles contrast with the existing rectilinear wall.

Interest: Variety of circle size and diversity of plant material.

Unity: Simple repetition of circular forms for an overall cohesive image.

Harmony: Planted buffer space to ease the visual transition between contrasting internal circular forms and external rectilinear walls. All paving meets walls and edges at 90° connections.

Spatial characteristics: A hierarchy of small, medium, and large spaces for different uses. Mounded grassy circle for amphitheater effect. Sunken stepped area next to pond for maximum enclosure.

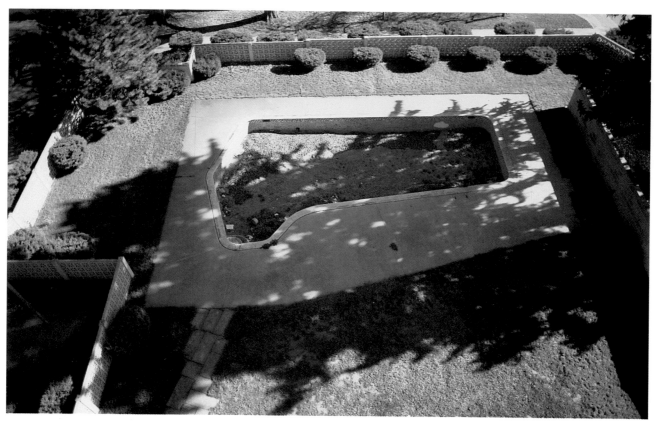

4-12. Before landscape renovations. Project 2.

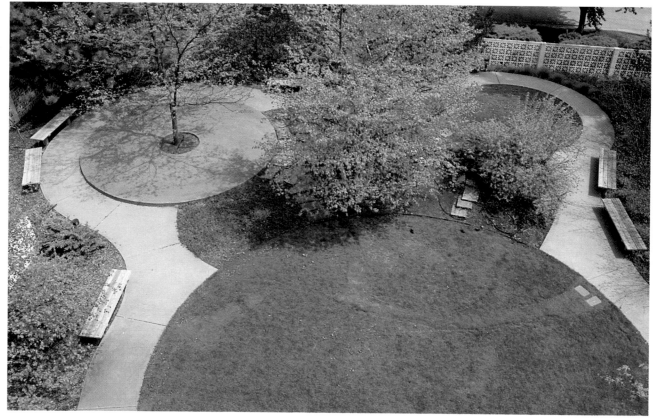

4-13. Completed landscape. Project 2.

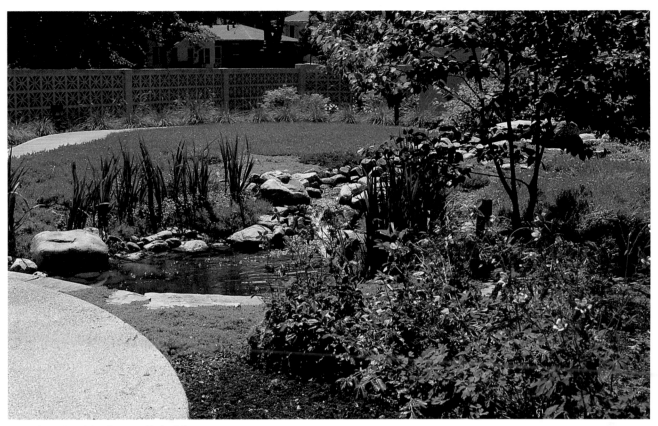

4-14. Completed landscape. Project 2.

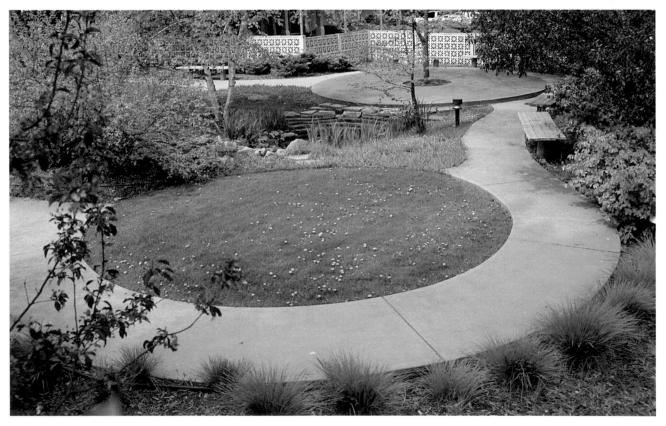

4-15. Completed landscape. Project 2.

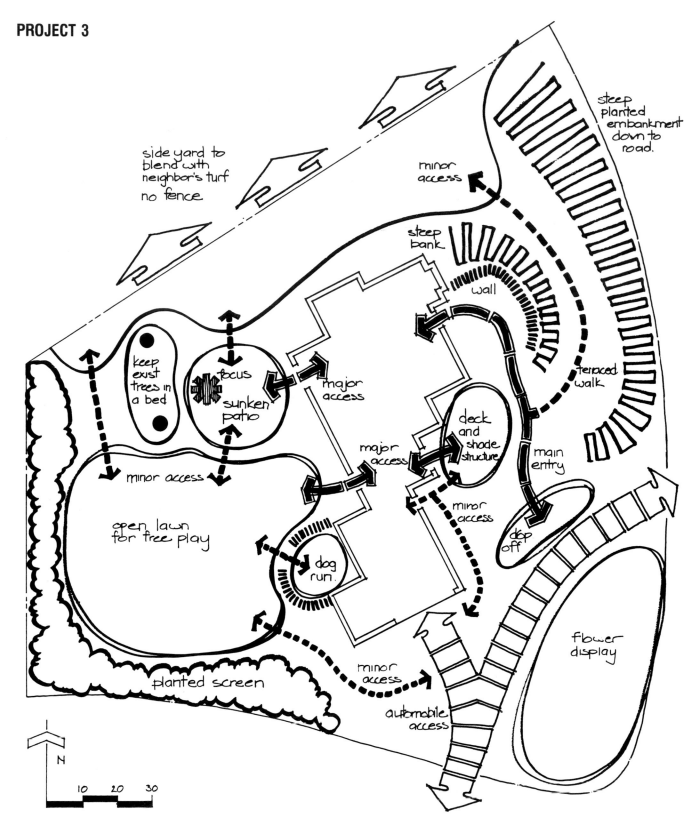

side yard to blend with neighbor's turf no fence

minor access

steep planted embankment down to road.

steep bank

wall

terraced walk

keep exist trees in a bed

focus

sunken patio

major access

deck and shade structure

main entry

major access

minor access

minor access

drop off

open lawn for free play

dog run.

flower display

minor access

planted screen

minor access

automobile access

N

10 20 30

4-16. Concept plan. Project 3.

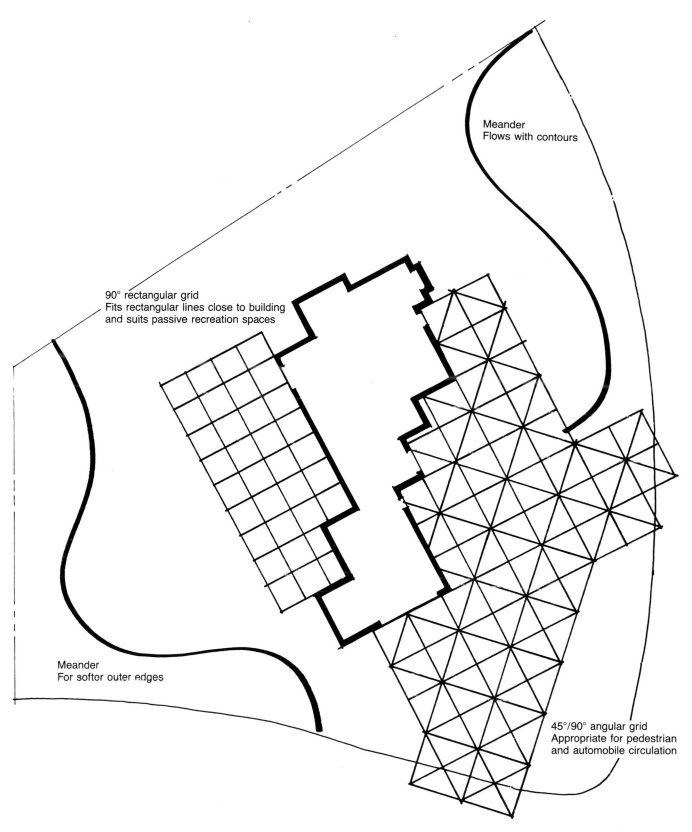

Meander
Flows with contours

90° rectangular grid
Fits rectangular lines close to building
and suits passive recreation spaces

Meander
For softer outer edges

45°/90° angular grid
Appropriate for pedestrian
and automobile circulation

4-17. Theme composition diagram. Project 3.

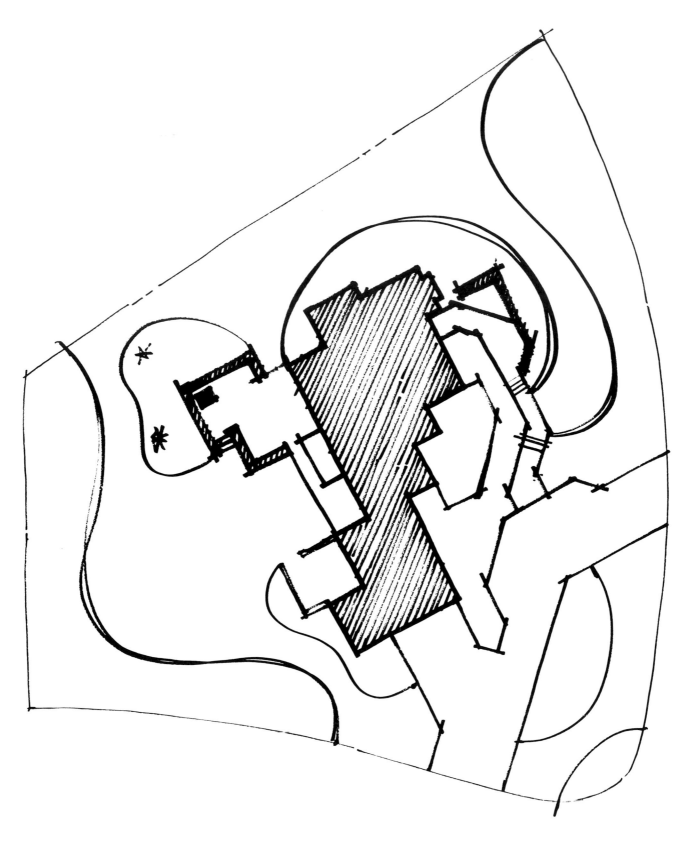

4-18. Form evolution diagram. Project 3.

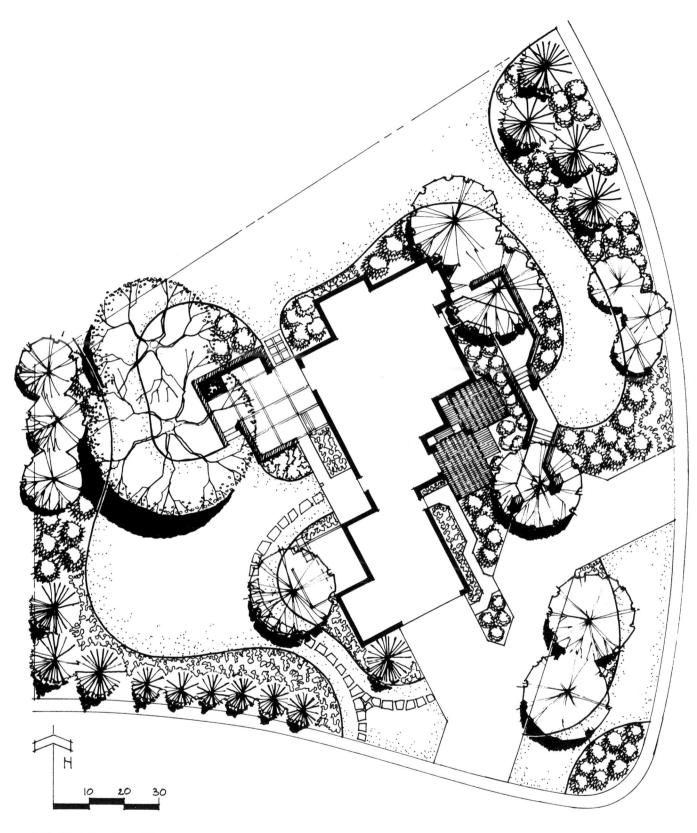

4-19. Final plan. Project 3.

10 20 30

Main Objectives

To create usable spaces for relaxation and free play

To provide for privacy without fences

To stabilize front slopes with terracing and plantings

To preserve existing mature trees

Structuring Themes

The 45°/90° angular grid (front drive and entry)

The 90° rectangular grid (front deck, back patio)

The meander (planted beds)

Principles of Design

Dominance: Spring and summer flowers provide the main visual impact. Two mature trees dominate the back area. A small fountain provides the focus to the patio.

Scale: Family living, intimate scale, small groups.

Interest: Texture and color compositions of plant material provide seasonal interest.

Unity and harmony: Indoor rooms connect directly to outdoor living areas, which flow smoothly into the rest of the landscape. Brick and wood siding material of the building extend into the landscape in the form of brick walls, deck, and shade structure. Grass areas flow uninterrupted from front to back, blending with the neighbor's yard.

Spatial characteristics: The entry includes the drop-off zone through a gateway accented by pillars and overhead canopy. It progresses through level and direction changes to a wide arrival area at the front door. In back the hedgerow defines the outer edge of the large space and the existing trees provide a powerful canopy roof. A small flight of steps links the large open area to the intimate enclosure of the sunken patio.

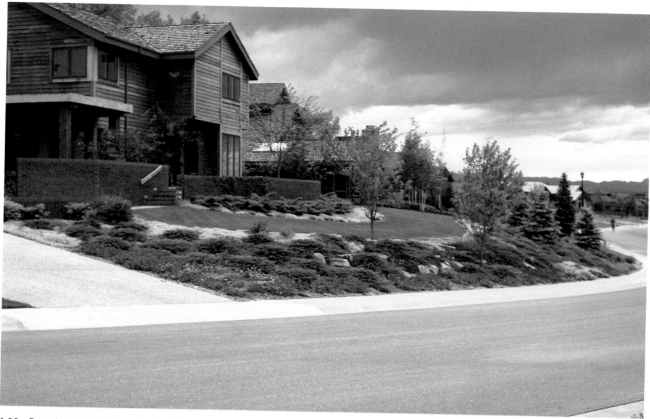

4-20. Completed landscape. Project 3.

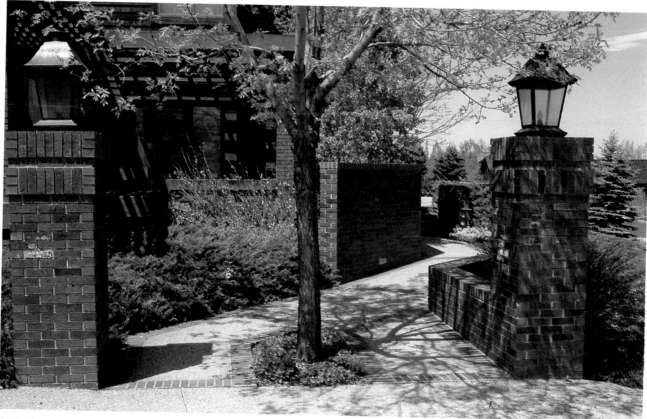

4-21. Completed landscape. Project 3.

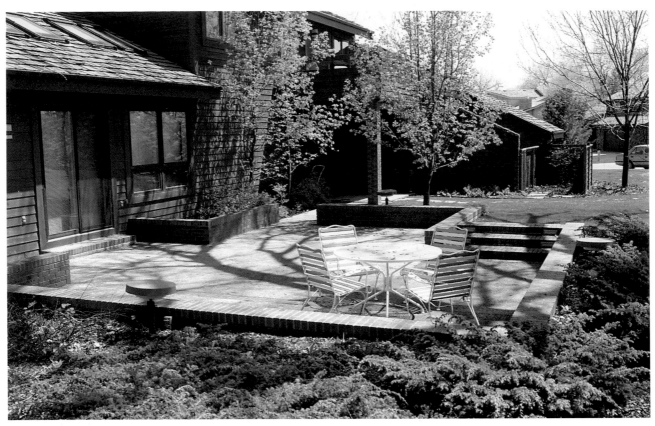

4-22. Completed landscape. Project 3.

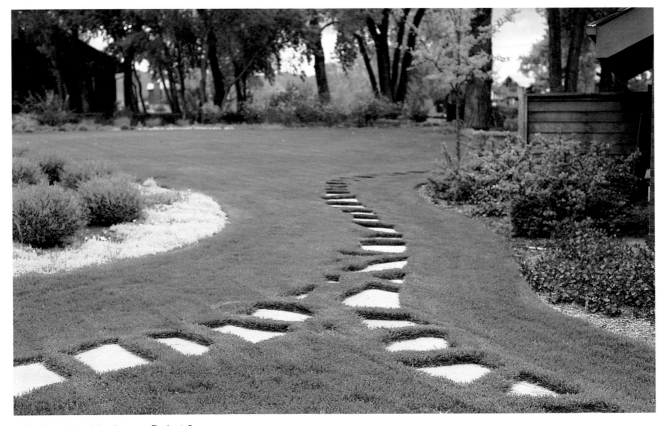

4-23. Completed landscape. Project 3.

PROJECT 4

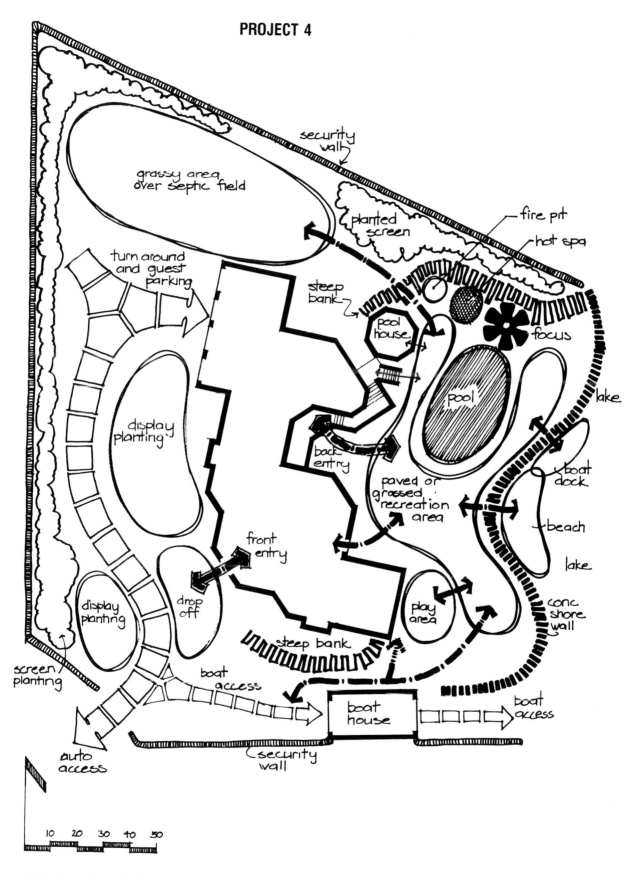

security wall

grassy area over septic field

planted screen

fire pit

hot spa

turn around and guest parking

steep bank

pool house

focus

display planting

pool

lake

back entry

boat dock

paved or grassed recreation area

beach

lake

front entry

play area

display planting

drop off

conc. shore wall

screen planting

steep bank

boat access

auto access

boat house

security wall

boat access

10 20 30 40 50

4-24. Concept plan. Project 4.

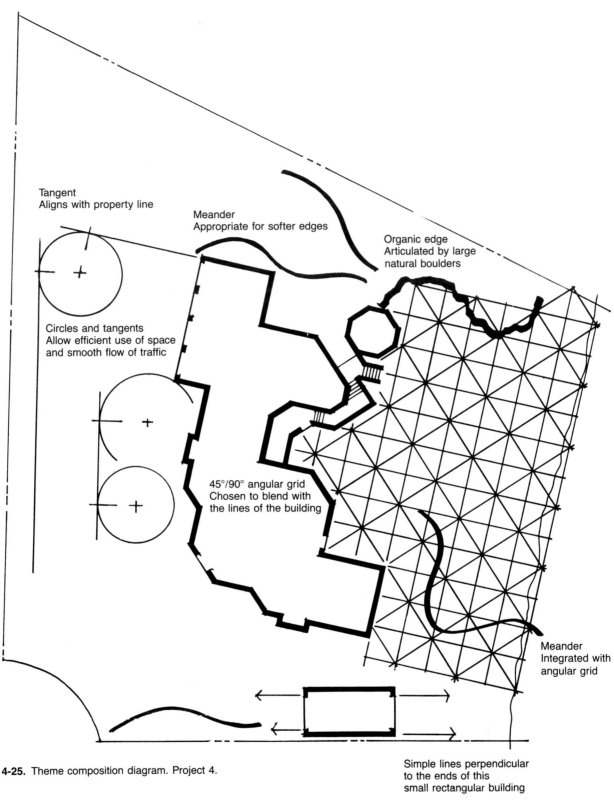

Tangent
Aligns with property line

Meander
Appropriate for softer edges

Organic edge
Articulated by large
natural boulders

Circles and tangents
Allow efficient use of space
and smooth flow of traffic

45°/90° angular grid
Chosen to blend with
the lines of the building

Meander
Integrated with
angular grid

4-25. Theme composition diagram. Project 4.

Simple lines perpendicular
to the ends of this
small rectangular building

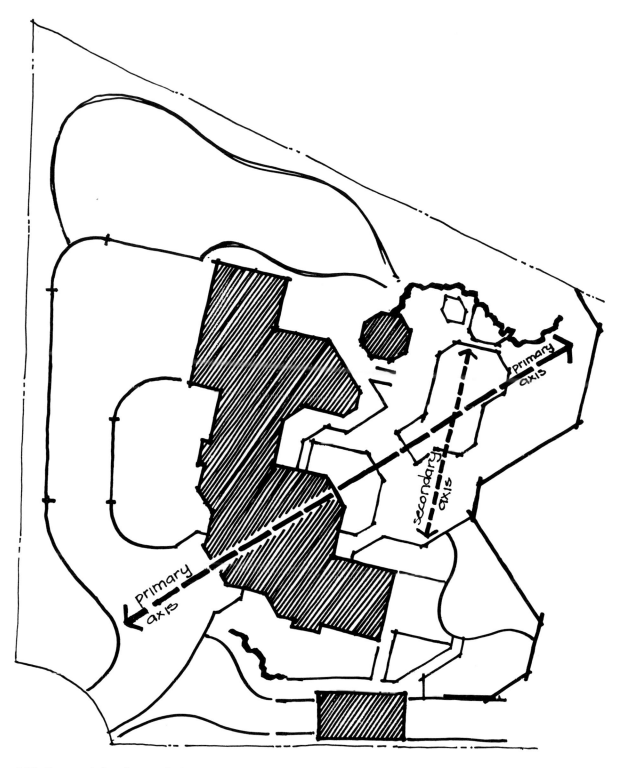

4-26. Form evolution diagram. Project 4.

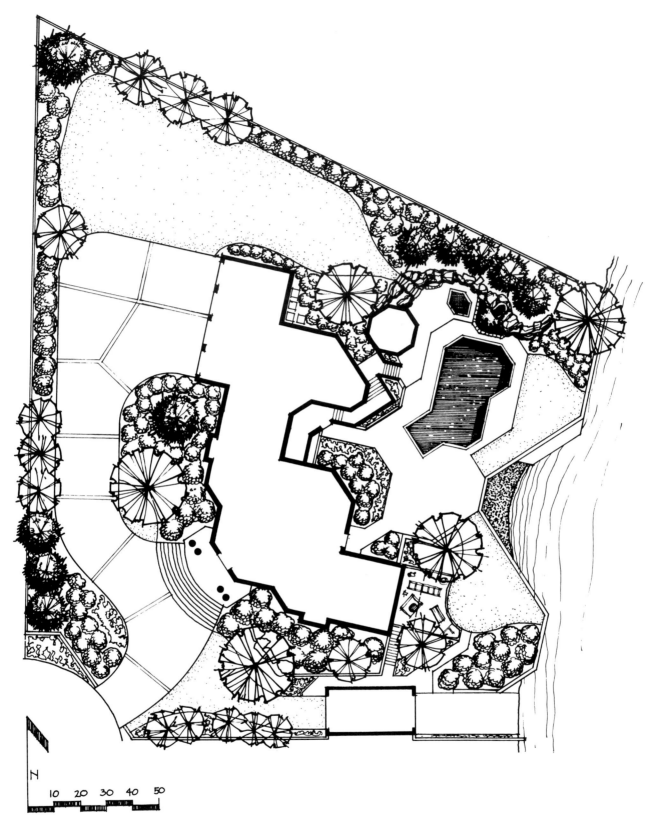

4-27. Final plan. Project 4.

N

10 20 30 40 50

PROJECT 4. DESIGN INTERPRETATION

Main Objectives

To satisfy owners' concerns for security and privacy

To maintain open views to the east

To maximize usable space limited by a large three-story building placed on a small lot

To match and blend the landscape with the symbolic architectural statement of success

Structuring Themes

Primary themes:

The 45°/90° angular grid (back area and lakefront)

Circles and tangents (driveway)

Secondary themes:

The organic edge (rock walls)

The meander (lawn edging)

Principles of Design

Dominance: White as the predominant color scheme. Exploitation of water in various forms and temperatures as the dominant element. Focal interest provided by the sound and sparkle of falling water.

Scale: Large trees to create a transition from the overpowering scale of the building to the human scale of the front entry and back recreation area. Rhythmic pavement banding on the drive to reduce apparent size of pavement.

Contrasts: Strong edge contrast between white architectural elements and dark natural elements (stone, plants, mulched ground).

Interest: Highlights of lavender color in awnings and patio furniture. Diversity of water environments (waves, waterfall, reflections, mists rising from pool). Seasonal flower color changes. Landscape lighting to accent focal areas and roofline.

Unity: The square and diagonal lines of the building carry into the structure of the built landscape elements.

Spatial characteristics: Drive and auto court make a transition from the narrow entrance, flowing around to a wide turnaround zone. Entry progresses from open drop-off zone, up majestic steps to a covered landing, then into the enclosed foyer. Play area takes advantage of a second level deck to provide an intimate covered area. Backyard has powerful spatial orientation toward the lake due to the tall building facades and the rock cliff. White color makes space feel larger. A smaller, intimate, partially enclosed space is tucked up against the cliff and orients south toward the pool. Subtle level changes down to the shoreline reinforce the outward orientation. Narrow, irregular, stepped linkage from lower paved space to upper grassed play area invite exploration.

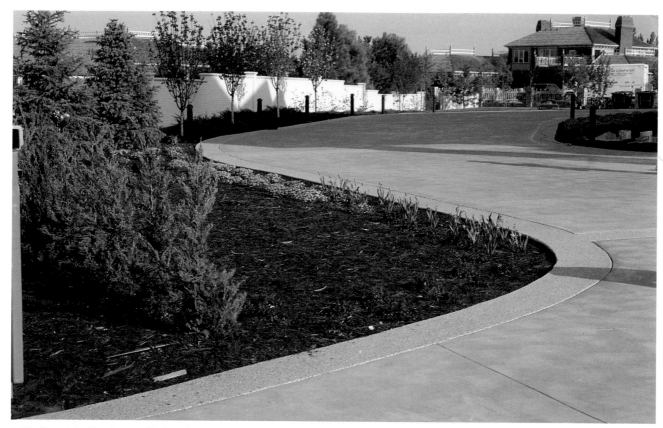

4-28. Completed landscape. Project 4.

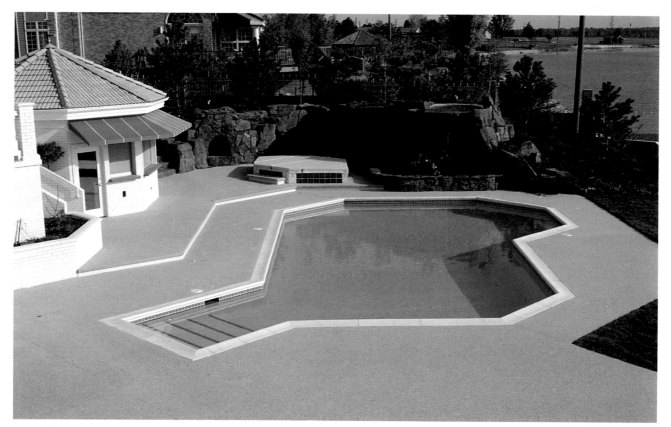

4-29. Completed landscape. Project 4.

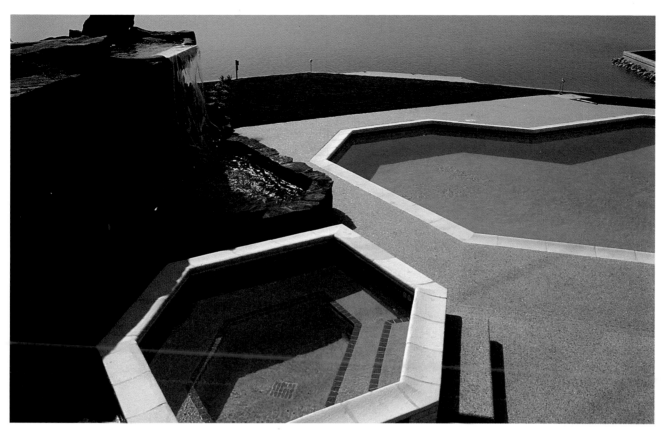

4-30. Completed landscape. Project 4.

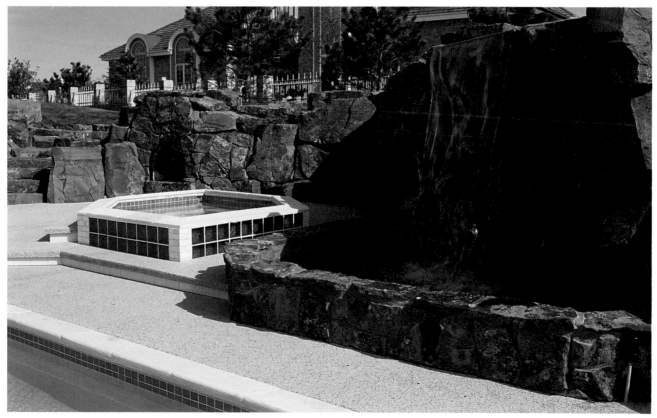

4-31. Completed landscape. Project 4.

PROJECT 5

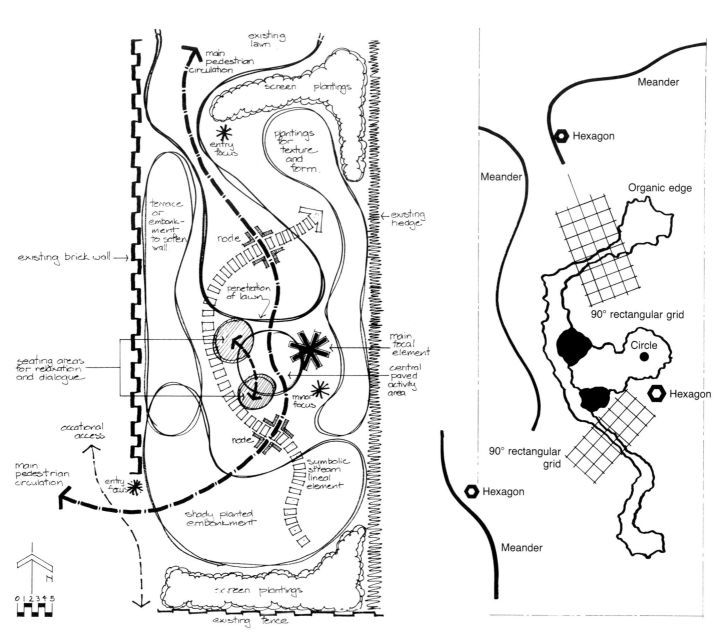

4-32. Concept plan.
Project 5.

4-33. Theme composition diagram.
Project 5.

Within figure 4-32:

existing lawn

main pedestrian circulation

screen plantings

entry focus

plantings for texture and form.

terrace or embankment to soften wall.

existing brick wall →

node

penetration of lawn

seating areas for relaxation and dialogue

occational access

main pedestrian circulation

entry focus

node

shady planted embankment

symbolic stream lineal element

minor focus

main focal element

central paved activity area

← existing hedge

screen plantings

existing fence

N
0 1 2 3 4 5

Within figure 4-33:

Meander

Hexagon

Meander

Organic edge

90° rectangular grid

Circle

Hexagon

90° rectangular grid

Hexagon

Meander

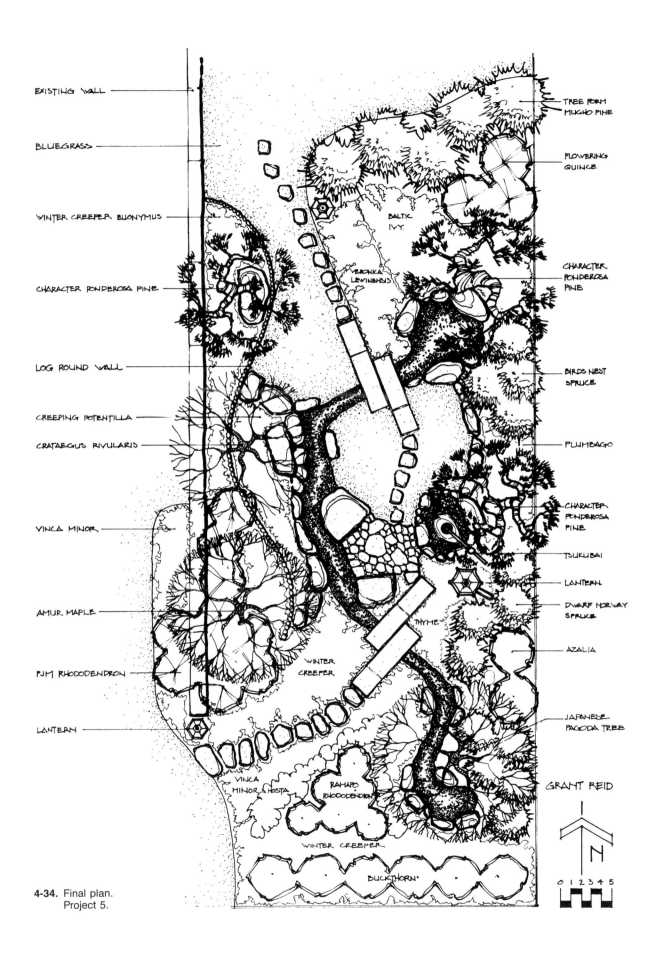

EXISTING WALL

BLUEGRASS

WINTER CREEPER EUONYMUS

CHARACTER PONDEROSA PINE

LOG ROUND WALL

CREEPING POTENTILLA

CRATAEGUS RIVULARIS

VINCA MINOR

AMUR MAPLE

PJM RHODODENDRON

LANTERN

TREE FORM MUGHO PINE

FLOWERING QUINCE

BALTIC IVY

PACHKA LEVINENSIS

CHARACTER PONDEROSA PINE

BIRDS NEST SPRUCE

PLUMBAGO

CHARACTER PONDEROSA PINE

TSUKUBAI

LANTERN

DWARF NORWAY SPRUCE

AZALIA

THYME

JAPANESE PAGODA TREE

WINTER CREEPER

GRANT REID

VINCA MINOR HOSTA

RAMAPO RHODODENDRON

WINTER CREEPER

BUCKTHORN

N

0 1 2 3 4 5

4-34. Final plan.
Project 5.

PROJECT 5. DESIGN INTERPRETATION

Major Objectives

To emphasize natural materials such as rocks, plants, earth forms, water, and log rounds

To display the idea of harmony between man and nature by integrating rectangular cut stone with natural river-worn stone

To create a sense of peace, quiet, and tranquillity

To symbolize passing time and timelessness, using white gravel to represent flowing water, and evergreens to represent constancy

Structuring Themes

Primary themes:

The organic edge (boulders, stepping stones, "stream")

The meander (log round wall, grass edges)

The 90° rectangular grid (bridge stones)

Secondary themes:

The hexagon (lanterns)

The circle (water basin)

Principles of Design

Dominance: Large boulders as seat rocks. Trickling water as a powerful visual focus and for gentle sound effects. Entries punctuated with small lanterns.

Scale: Intimate scale, one or two people.

Contrasts: White gravel "water" next to dark grey rocks; rectangular stone slabs bridging soft rounded stone borders; fine texture of small pebbles next to larger rocks.

Interest: Texture and form variations in plant materials; seasonal changes, brief episodes of spring and fall color.

Unity: "Stream" and walkway as two interweaving and unifying lineal elements. Repetition of smooth river-worn stone throughout.

Spatial characteristics: Narrow entryways transitioning to a wider paved stopping point. Level changes with steps and terracing.

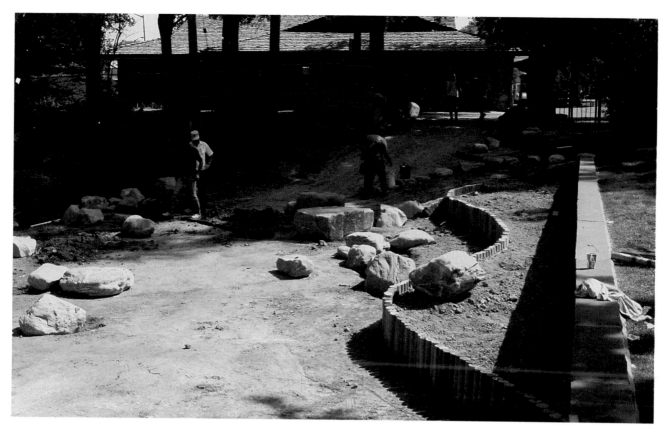

4-35. During landscape renovations. Project 5.

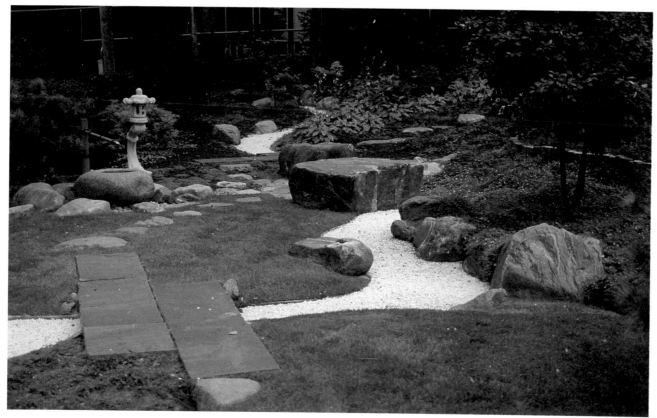

4-36. Completed landscape. Project 5.

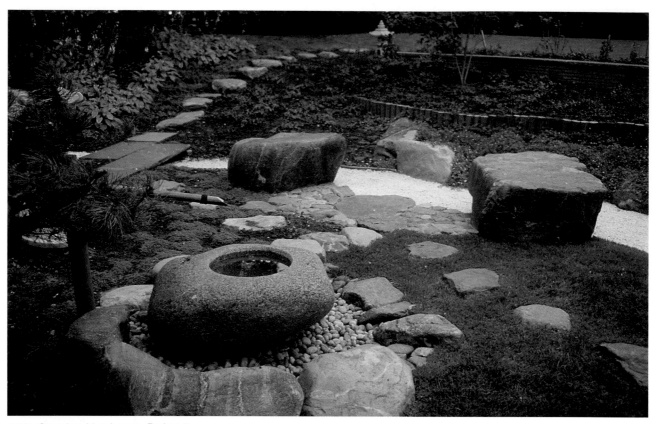

4-37. Completed landscape. Project 5.

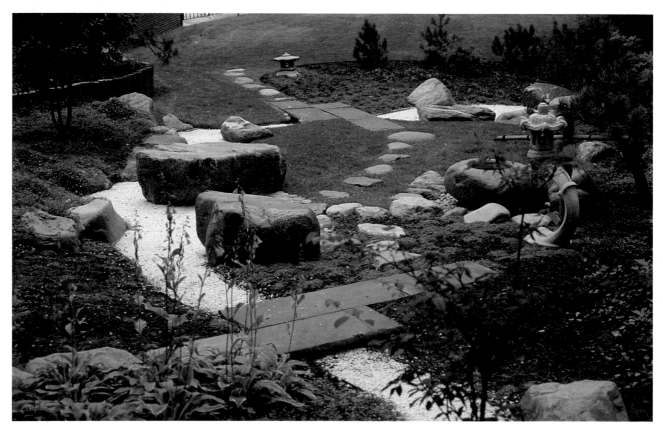

4-38. Completed landscape. Project 5.

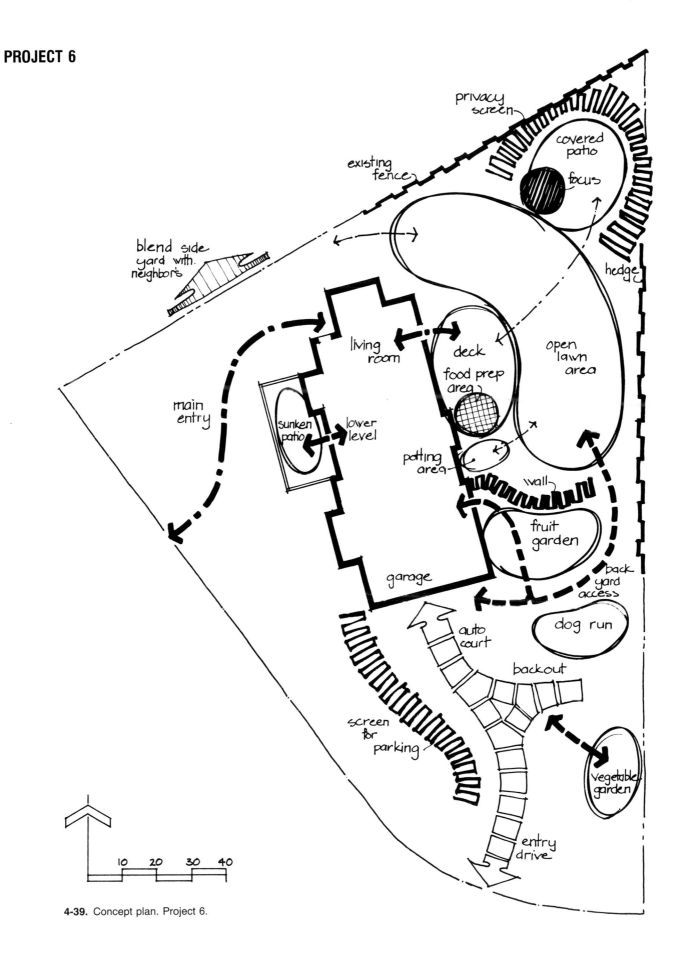

4-39. Concept plan. Project 6.

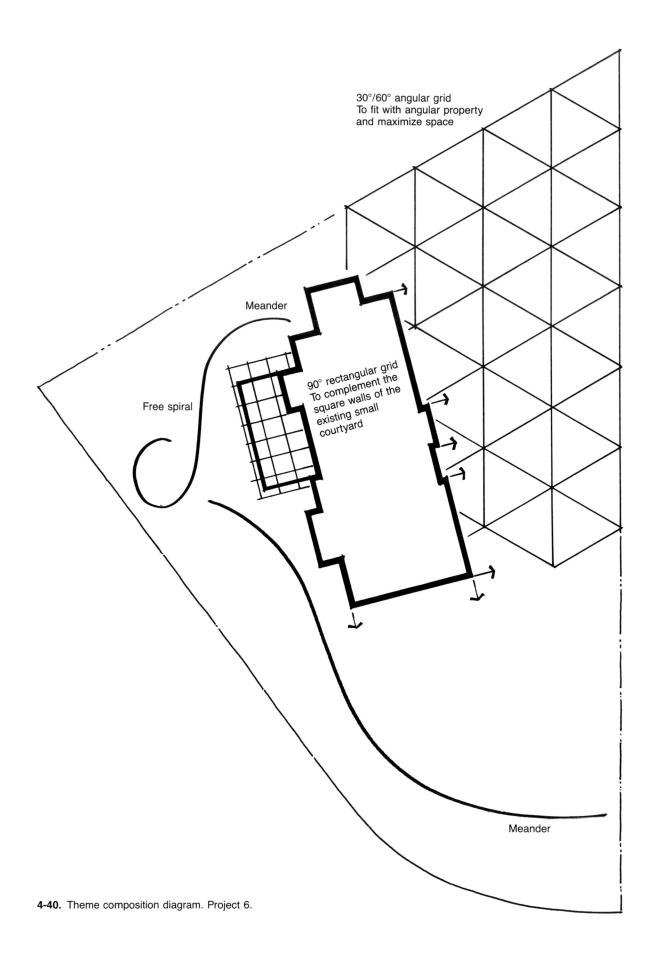

30°/60° angular grid
To fit with angular property
and maximize space

Meander

Free spiral

90° rectangular grid
To complement the
square walls of the
existing small
courtyard

Meander

4-40. Theme composition diagram. Project 6.

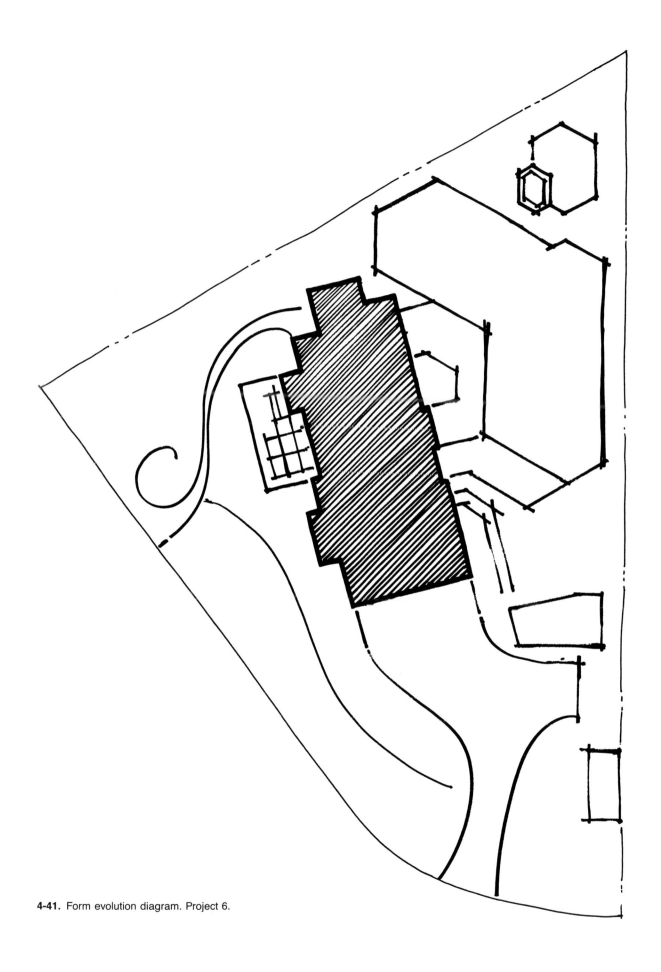

4-41. Form evolution diagram. Project 6.

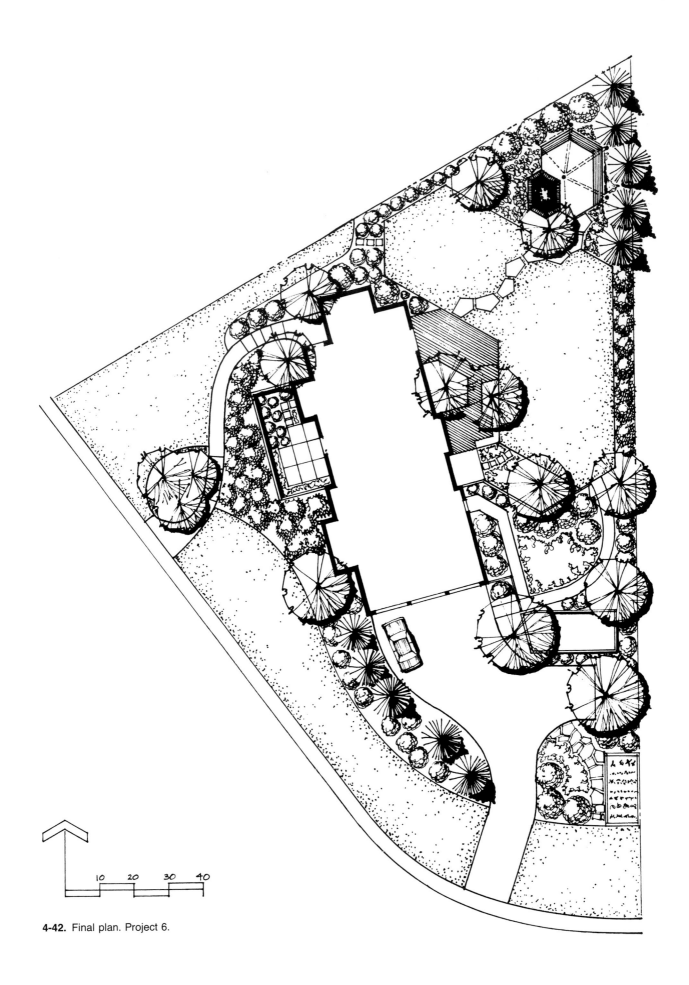

10 20 30 40

4-42. Final plan. Project 6.

PROJECT 6. DESIGN INTERPRETATION

Main Objectives

Easy transition from street to front entrance

Provide a secluded shady retreat garden

Integrate edible plantings

Structuring Themes

The 30°/60° angular grid (deck and backyard)

The 90° rectangular grid (sunken patio)

The meander (front beds and driveway)

The free spiral (front walk)

Principles of Design

Dominance: The shade structure provides dominant focus within backyard. A small fountain becomes a secondary focus in the retreat garden.

Scale: Emphasis on family scale. Two intimate spaces designed for two to four people.

Rhythm: Repeated use of angular pavers provides a rhythmic link between the deck and the retreat garden.

Interest: Angular changes of direction in edging bring a dynamic feel to back spaces. Plants add diversity of form and color.

Unity and harmony: Backyard is unified within the repetitive angles of the triangular grid. Meandering flowing lines link all front yard spaces and elements. Connections of landscape elements to building join at strong right angles. Planted beds soften the transition between curved and square forms in the front.

Spatial characteristics: Entry walk flows up the sloping front yard in an "S" configuration with two flights of steps. The sidewalk expands at each end to convey a sense of beginning and arrival. Planted screens and fences in the back shape the larger outdoor room. A high degree of enclosure occurs in the retreat garden with the addition of hedge plants and an overhead shade structure. The roof panels spiral down to force an even higher degree of enclosure at one edge of the small space.

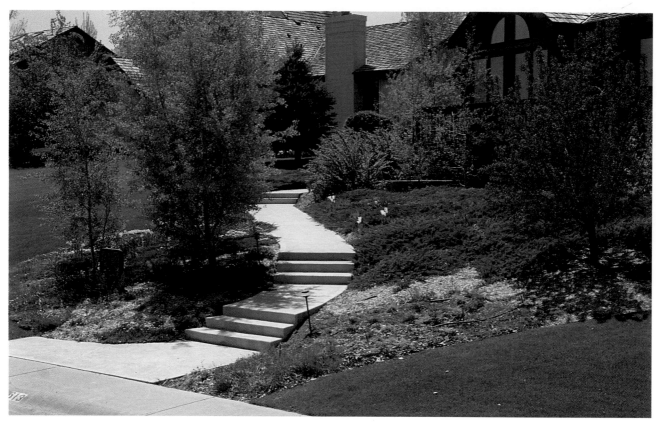

4-43. Completed landscape. Project 6.

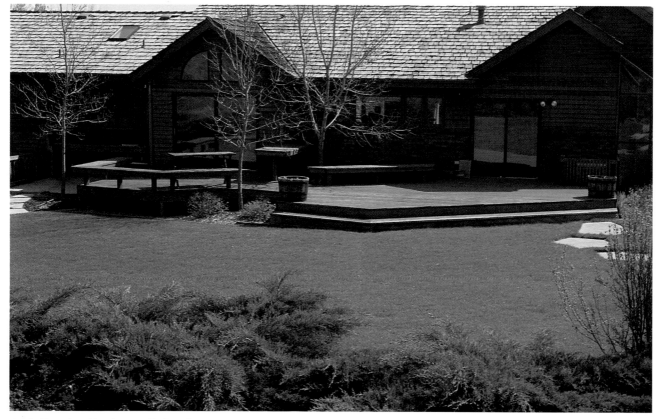

4-44. Completed landscape. Project 6.

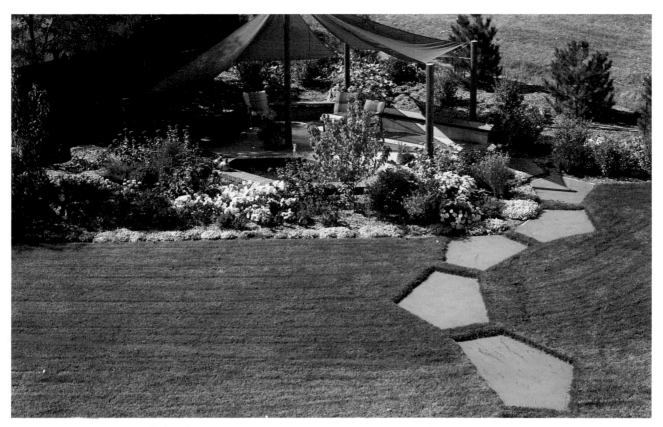

4-45. Completed landscape. Project 6.

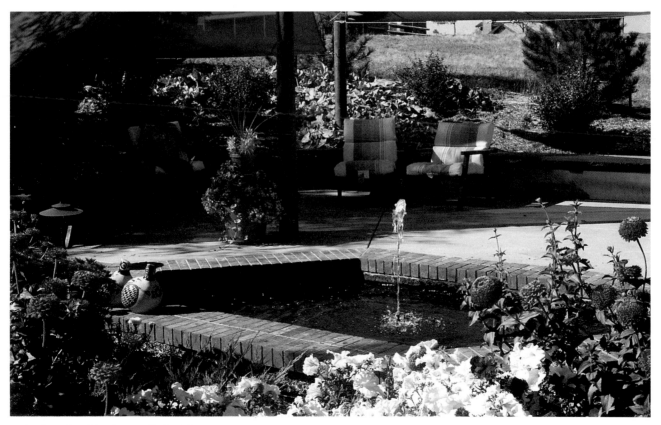

4-46. Completed landscape. Project 6.

5. Beyond the Rules: Anomalous and Provocative Design

The previous chapters put forward guidelines that are useful tools for developing strong professionally competent design solutions. By following the do's and don'ts, many typical faults of weak design may be avoided. These guidelines will help you achieve harmonious, unified designs, at once interesting and responsive to the client's needs and to the site or environmental context. But, they are only guidelines, and although it would be wise to master them first, sometimes it is necessary to bend or even break the rules. *Anomalous designs* deviate from the normal. By definition they contain some attributes that will differ from accepted standards.

Generally we expect good design to be functional, comfortable, reasonable in cost, easy to build and maintain, and liked by all the users. If we ignore the norm and push the boundaries of creative design, very likely we will have to violate one or more of these expectations. Very possibly the resulting landscape spaces may be expensive to build, impractical, difficult to maintain, or offensive to some people. Why bother? Because it is also possible that these different ideas may be exciting, provocative, and—more importantly—the basis for innovation.

The introduction of a new material or construction process may be very expensive at first but with frequent application, costs may drop significantly. An impractical aesthetic statement may inspire a more practical adaptation. A ridiculous, eccentric place may later become a successful tourist attraction. Of course there is no guarantee of success. Quite the reverse. Anomalous design is risky, but, knowing the risks and being well grounded in the safer basics, you may be ready to try the extraordinary.

In this chapter we will look at some outdoor designs that are a little unusual. From your own value system, you decide whether they are good or bad, valuable or useless, fun or boring. The possibilities are limited only by your imagination. The following small number of examples may stimulate your own creative power.

ACUTE ANGLE FORMS

Previous chapters suggested that acute angles be avoided, but under certain conditions and with careful treatment, they can be successfully incorporated.

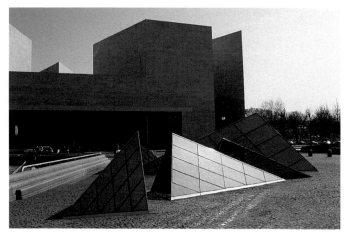

5-1.

The well-known architect I. M. Pei has effectively incorporated sharp corners into many of his structures. They are strikingly different from the normal rectilinear corner.

Similarly, the forms in these urban plazas have many sharp edges. Their skillful positioning prevents them from becoming a hazard.

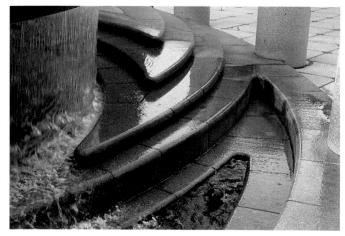

5-3.

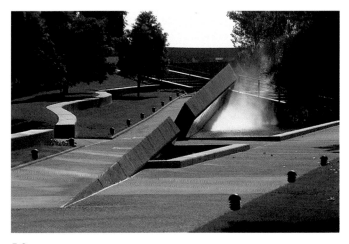

5-2.

This fountain in Singapore incorporates stepped acute angle forms with a water sculpture. Together they enhance the dynamic qualities of moving water. To avoid point breakage the tips have been rounded.

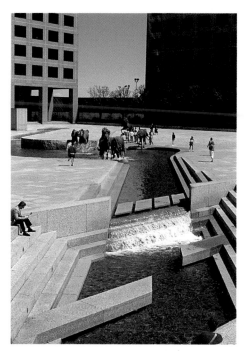

5-4.

Touching circles have inherent acute angles. Paving infill at the same level overcomes the problem on the ground plane, however, and rounding the hedge corners softens the edge in the vertical plane in this design.

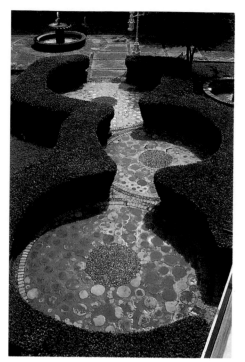

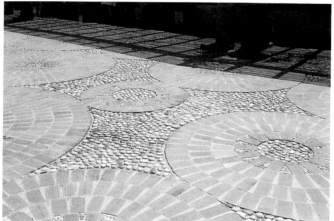

5-5.

5-6.

These triangular panels are used to form an outdoor tension structure. The sharp corners become a structural necessity rather than a liability.

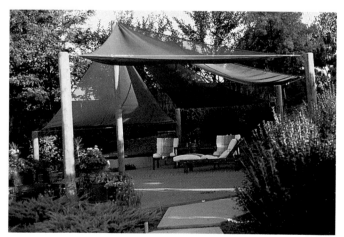

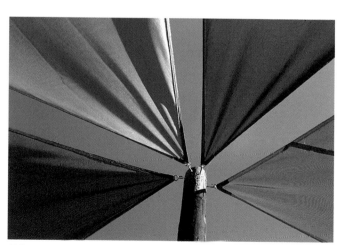

5-7.

5-8.

COUNTER FORMS

Deliberate nonalignment of form introduces an element of tension in the landscape.

A tilted rectangle or a straight wall bearing no relationship to the circle center shows this.

5-9.

5-10.

Conflicting forms introduced as counterpoints elicit a specific emotional response.

The jarring, skewed relationships of ground plane patterns and wall design raise the visual discomfort level of this plaza in Denver, Colorado.

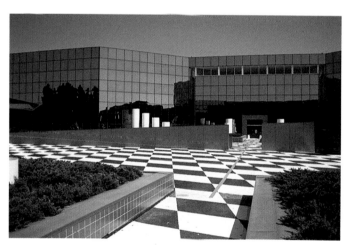

5-11.

"Not-quite-right" forms are another way to introduce tension deliberately. Our minds have an image of the perfect condition or form and subconsciously strive to fix it.

We see a dented circle and subconsciously try to round it out to the pure form.

5-12.

We want to make almost touching forms touch.

5-13.

We wonder what is disconcerting about two walls that are almost parallel but not quite.

Some observers may see only a mistake and will leave disappointed. Others may sense the deliberate introduction of disharmony and search for a reason. There may be none other than to disturb the viewer.

5-14.

Overlapping counterforms are contrasting forms, overlaid one on top of or through the other, bearing no apparent relationship to each other.

If, for example, a meandering planting bed or ground plane line is superimposed over a rectilinear seat wall without any recognition of the wall shape, the points of overlap set up tension points in the landscape. These can be somewhat reconciled by perceiving the separate entities of form.

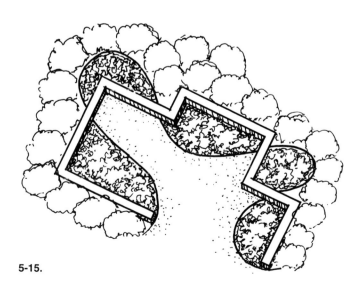

5-15.

In this pedestrian mall in Singapore several contrasting forms exist: curving walls, straight bands, irregular stone edges, rectilinear steps, and three different paving patterns. All are mixed together in whimsical irrational relationships. Nothing is aligned. Perhaps the rules were broken to create a fanciful mood.

5-16.

The playful qualities of this paving pattern also express a frivolous abandonment of any rigid structure (Del Mar, California).

5-17.

DECONSTRUCTION

This is the deliberate design of objects and spaces to indicate a state of destruction, decay, or incompletion. Perhaps it is merely a gimmick to grab the user's attention or perhaps it is rooted in the original goals and concepts of the design. Although this approach may be abnormal, it is by no means new. Many classical English gardens had "ruins" specially constructed to create a sense of belonging to an earlier time.

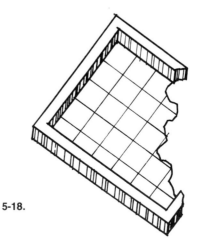

5-18.

In this modern example the wall units have been carefully placed in the landscape to create a fall-out composition. To be sure, the blocks are difficult to mow around, but there is an interesting image of organized chaos captured in the shape of the hole in the wall and the contrasting composition of blocks on the ground (Stuttgart, Germany).

5-19.

This stone garden not only exploits the diversity of shape, texture, and color possible in rock, but also, in the tilted partially buried cube, expresses an underlying message.

5-20.

Adjacent to one side is a bent and cracked concrete walk with no real function but it complements the cube placement, and together they evoke an image of the unseen force of gravity (Sindelfingen, Germany).

5-21.

This fallen obelisk is also a static expression of a dynamic process. Placed as it is across the wall, the obelisk has a deliberate fracture line and a subtle bend away from the pure straight line. It is not hard to imagine the falling motion that could have placed it there (Sindelfingen, Germany).

5-22.

The jolt of the unexpected is a goal of the designer who takes new-looking materials and familiar structures and makes them appear aged, broken, partially destroyed, or decayed. This type of imagery may have added meaning if there is some underlying conceptual message related to a destructive process such as war, earthquake, erosion, or fire (Wellington, New Zealand).

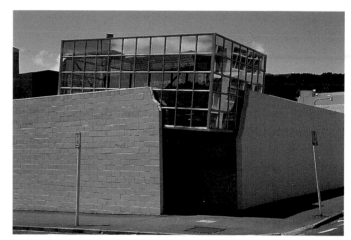

5-23.

The wall and associated building shown here could be an entertaining excursion into deconstructive architecture, or they may be a reminder that this part of the world is prone to earthquakes (Wellington, New Zealand).

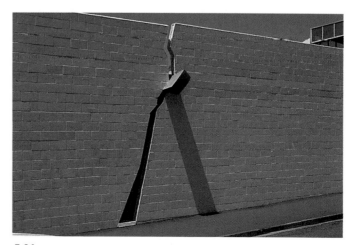

5-24.

SOCIAL AND POLITICAL LANDSCAPES

No mastermind designer was responsible for the design of People's Park in Berkeley, California in the early 1970s. Its form evolved as a result of a social phenomenon. Half a city block near the university had lain muddy and vacant for years. Suddenly, with no apparent leadership, people began to "improve" the site. Sod was rolled out over lumpy ground; play structures were brought in and vegetable gardens cultivated. It was a period of feverish construction with no master plan or director. The resulting form was not an award-winning design if judged on normally accepted criteria of excellence. The place was alive, however, with the vibrancy of diverse people working and playing together in a space they deemed useful and beautiful. It was both a social and political statement. To many the park was a very successful design. But its life was to be just a few short weeks. To those in power it was an unacceptable deviation from the normal way things were supposed to be done. The park was undone and its form changed into a more traditional (but less used) manicured grass lawn and a ball court.

5-25.

5-26.

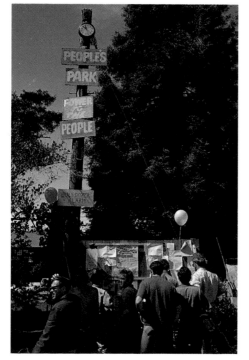

5-27.

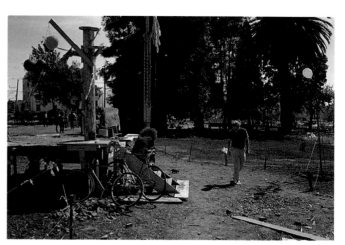

5-28.

At the 1989 National Garden Show in Frankfurt, Germany, one of the theme gardens was based on the issue of environmental degradation. The left half showed a comfortable lush green place, the right half total devastation. Landscape form was used to communicate a social message. Was it attractive? No. Was it useful? No. Was it provocative? Absolutely!

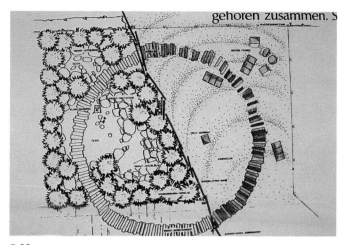

5-29.

5-30.

ECCENTRIC LANDSCAPES

People branded as eccentric by the rest of us are by definition unusual but harmless. They can also be very creative and energetic. Landscape spaces created by such people often break or ignore the rules and may contain some "crazy" interesting elements of form, color, and texture.

This owner-built patio has a severe slope and associated furniture with uneven supports. The wall is a playful conglomeration of various masonry and ceramic products including teacups (Auckland, New Zealand).

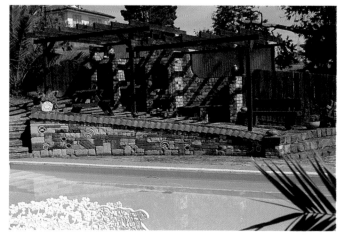

5-31.

5-32.

Stone pebbles and colored glass are the basic veneer materials for this garden in Seattle, Washington.

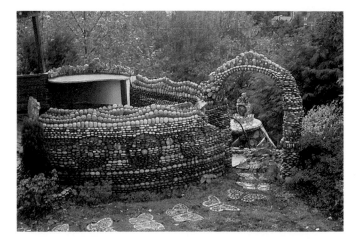

5-33.

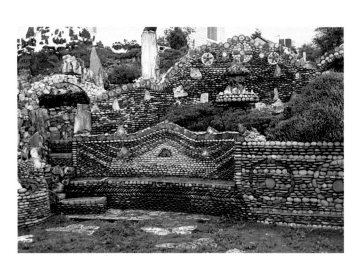

5-34.

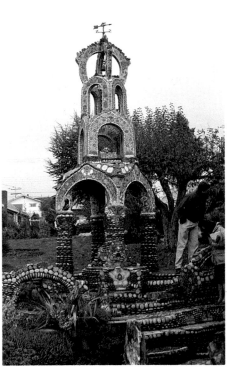

5-35.

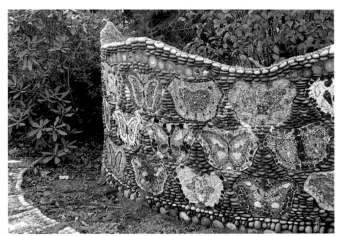

5-36.

LANDSCAPES OF DISTORTION AND ILLUSION

Spatial illusions can be useful in the design of outdoor environments. The end of a long, narrow space can be made to appear closer or farther away by manipulating the shape and vertical rhythm of the space.

Elements evenly spaced within a rectangular framework.

Focus

Elements compressed towards the front.

Focus appears closer.

Viewpoint

Elements compressed towards the back.

Focus appears farther away.

5-37. Perspective illusion.

The city of Wellington, New Zealand has striking outdoor mural art.

A vacant lot becomes a fanciful seascape with illusions of space beyond the wall and of seashells floating in space.

5-38.

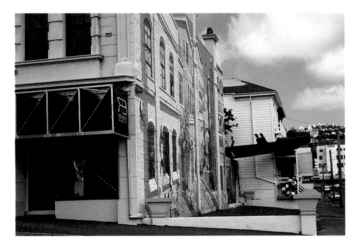

Viewed from the front this old building has a flat facade on its right side.

5-39.

But a new world unfolds when this same facade is viewed straight on. The artist has captured the powerful perspective depth of a Venetian plaza and canal. The chimneys skillfully blend into the tops of pillars whose painted shadows further intensify the spatial illusion.

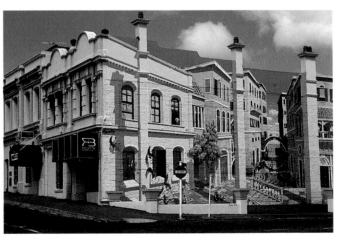

5-40.

In the same city stand several other old buildings decorated with spatial illusions.

5-43.

5-41.

5-42.

5-44.

Contextual distortion is familiar objects used out of their usual manner, place, or context.

This mannequin garden could be offensive or disturbing to many people and certainly not very functional. But there would be few observers who would not be surprised by this contextual aberration (Frankfurt, Germany).

5-45.

The designer of this maze garden is playing a trick of scale distortion (Frankfurt, Germany).

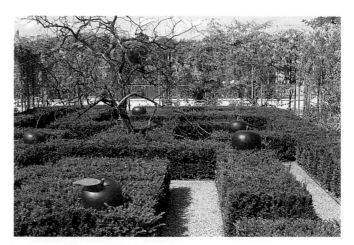

5-46.

It seems impossible but these round stones somehow hold themselves up to form a garden archway. In fact it is very secure, but the effectiveness of the design lies in the illusion of structural frailty, the possibility that it will fall apart easily (Russell, New Zealand).

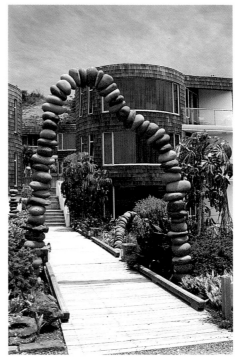

5-47.

It is a rare designer who does not run into design block now and then or who never finds himself repeating comfortable solutions. The time will come to reject notions like "It's worked well before so I'll use it again here" or "It can't be done" or "They will never buy that." The time comes to say "What if . . . ? Why not? . . . How about . . . ? There must be a better way to do this . . . That's pretty strange but let's give it a try!"

In this defiant mode the designer may deliberately adjust the landscape toward images that produce a disquieting experience. The observer may be thrown off balance and into discomfort or uneasiness. The images may challenge deeply held beliefs or shatter expectations. There is legitimacy in the application of incongruity, especially when used sparingly. The more important value lies in the designer's responsibility to challenge the norm.

Appendix: Guide Patterns and Geometric Construction Methods

The following guide patterns and geometric construction methods are presented in the same order as referred to in the preceding chapters.

1. 45°/90° angular theme pattern

2. 30°/60° angular theme pattern

3. Concentric hexagons

4. To construct a regular hexagon

5. To construct a regular pentagon

6. Concentric circles and radii theme pattern

7. Circle segments theme—quarter circles

8. Ellipses

9. To construct a customized ellipse—rectangle method

10. To construct an ellipse—in-field method

11. To construct a golden mean rectangle

1. 45°/90° Angular Theme Pattern

A-1.

2. 30°/60° Angular Theme Pattern

A-2.

3. Concentric Hexagons

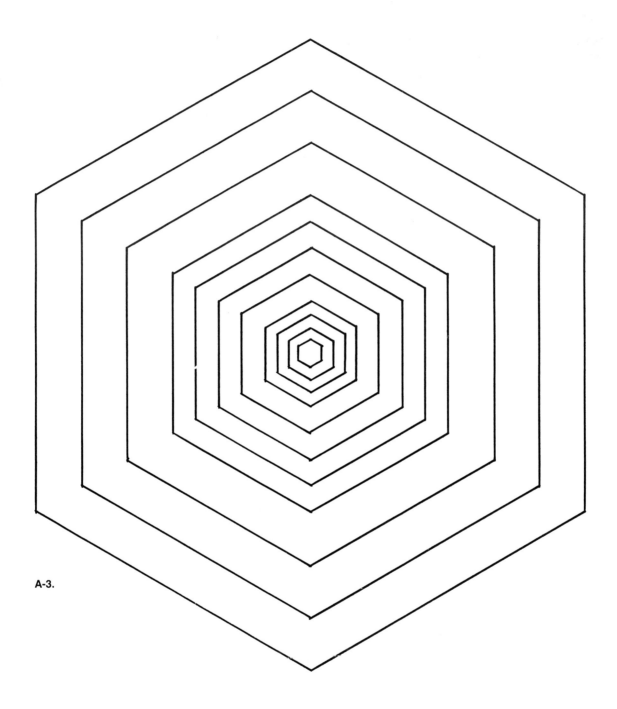

A-3.

4. To Construct a Regular Hexagon

1. Draw intersecting vertical and horizontal lines AB, CD.

2. Choose the size of hexagon desired (shortest dimension). Draw two verticals intersecting AB equidistant from O. Their distance from O should be half the desired hexagon size.

3. Using a 30°/60° triangle, draw two diagonal lines through O at a 30° angle. These intersect the verticals at E, F, G, H. If the wide part of the hexagon is the determining factor, draw the diagonals first, then the two verticals GE, EF.

4. Slide the triangle above and below O to draw 30° angles from the points of intersection EF and GH to form the outside of the hexagon.

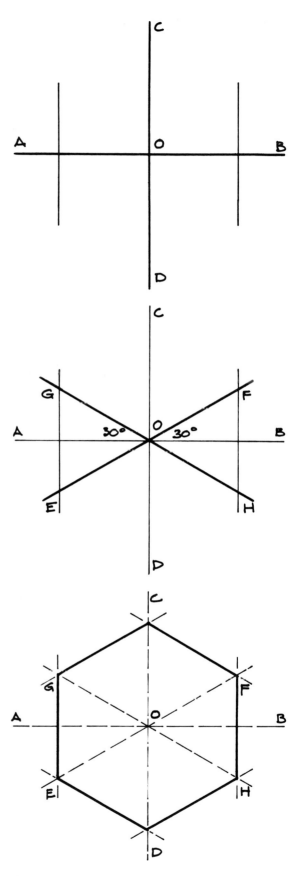

A-4.

5. To Construct a Regular Pentagon

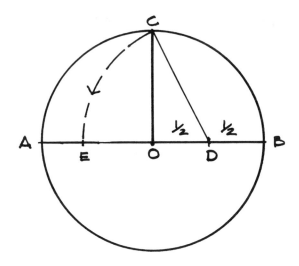

1. Make a circle with diameter AB. Draw an upright OC from the center. Divide OB in half to get D. Draw an arc with radius CD to mark point E on AO.

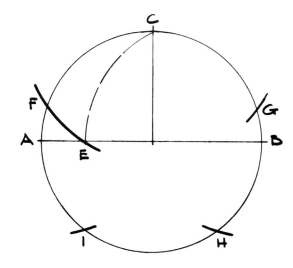

2. Draw another arc with its center at C and a radius CE to work the points F and G on the circumference. Keeping the same compass setting and using F and G as center points, mark I and H, respectively.

3. Join the points C, G, H, I, F to form the pentagon (Crichlow, 1970).

A-5.

6. Concentric Circles and Radii Theme Pattern

A-6.

7. Circle Segments Theme—Quarter Circles

A-7.

8. Ellipses

9. To Construct a Customized Ellipse—Rectangle Method

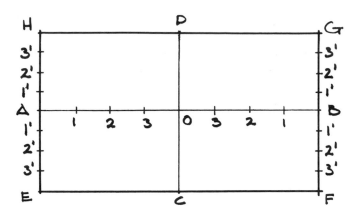

1. Draw the major and minor axes AB and CD to whatever size and proportion desired to fit the space. Construct a rectangle about their ends. Divide AB into eight equal parts. Divide EH and FG also into eight equal parts.

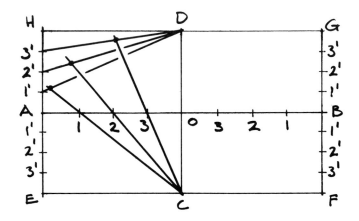

2. From D draw lines to 1′, 2′, and 3′. From C draw lines through 1, 2, and 3 and extend to intersect the previous set. Place a dot where the lines through 3 and 3′ intersect, similarly with 2 and 2′, 1 and 1′.

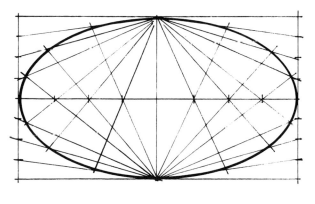

3. Repeat for the other three quadrants, then join the dots with a smooth curve to form the ellipse (Pearson, 1968).

A-9.

10. To Construct an Ellipse—In-Field Method

For a landscape crew in the field, this method is useful for layout of an elliptical form.

1. Set up string lines at 90° for the major axis AB and the minor axis DC. These will be the widest and narrowest parts of the ellipse, respectively.

2. Measure AO and take the tape measure to D. Using the same distance, mark points F^1 and F^2 located on AB. Drive metal pins or rebar into the ground so that they do not move easily.

3. Take a piece of smooth synthetic string and on the string make two marks that are exactly the same distance apart as AB. Tie the string to the pins so that the marks are at F^1 and F^2. Take a short piece of plastic pipe and, pulling the string tight, scribe an oval letting the string slide around the pipe (Pearson, 1968).

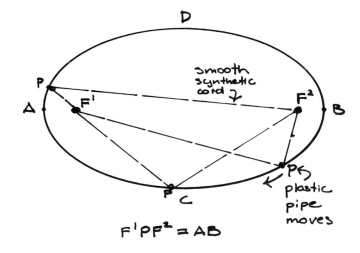

A-10.

11. To Construct a Golden Mean Rectangle

Draw a square and divide it in two down the middle, from midpoint to midpoint of two parallel sides. Add a diagonal line to the half square, and using that as a radius, scribe an arc to intersect the extended base of the square. This now forms the long side of the new rectangle. Its proportions are such that if a square is constructed on the short side, the remaining smaller shape is another golden mean rectangle. This process of diminution can continue as long as it is possible to draw (Crichlow, 1970).

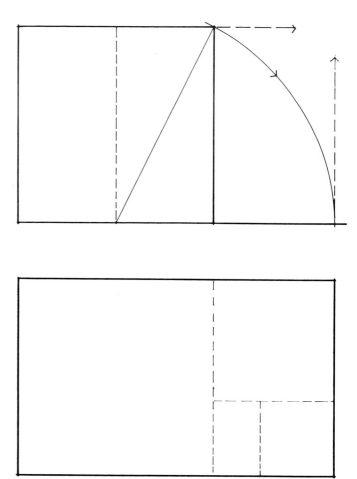

A-11.

REFERENCES

Crichlow, K. 1970. *Order in Space.* New York: Viking Press.

Pearson, G. 1968. *Geometric Drawing.* 2d Ed. Oxford: Oxford University Press.

Stubblefield, B. 1969. *An Intuitive Approach to Elementary Geometry.* Belmont, Calif.: Brooks/Cole Publishing Co.

Index

Abstractions of nature, 46
Activity: nodes, 7; zones, 6
Acute angles: problems of using, 19, 23, 28, 66, 69, 78; in successful designs, 135, 136
Aesthetic satisfaction, 82
Analogues of nature, 47
Angular themes: fourty five degree/ ninety degree, 18–20, 43; thirty degree/ sixty degree, 21–25, 43. *See also* Irregular polygons
Anomalous designs, 134–38
Arcs and tangents, 34–37, 44
Architectural illusions, 146, 147

Balance, 91, 92
Beyond the rules, 134–38
Blobs. *See* Bubble diagrams
Breaking the rules. *See* Beyond the rules
Bubble diagrams, 6, 7, 10, 11, 16. *See also* Concept plans
Buffer space, 78, 79

Case studies, 95–133
Chaos, 83, 87, 140
Circles and radii, 32–34, 44
Circle segments, 38–40, 44
Circles on circles, 27–31, 44
Circular themes, 27–41. *See also* Arcs and tangents; Ellipses, formal
Client needs. 1. *See also* Program
Clustering, 74 77
Color, 13
Completed landscapes, of case studies, 101, 102, 106, 107, 113, 114, 120, 121, 125, 126, 132, 133
Complexity, 70. *See also* Diversity; Chaos
Concentric: circles and radii, 32, 33, 44, 155; hexagons, 152
Concept plans: for case studies, 96, 103, 108, 115, 122, 127; other examples of, 7, 43, 55
Concepts: general philosophical, 1–5; specific functional, 5–11
Conflict, 7, 137
Contrast, 89
Counter forms, 137–39
Curvilinear. *See* Meander

Deconstruction, 139–41
Defiant mode, 148
Design interpretation, of case studies, 100, 105, 112, 119, 124, 131

Disharmony, 84–86, 138
Dispersal. *See* Fragmentation
Distorted landscapes, 145–48
Diversity, 88
Dominance, 88–90

Eccentric arrangement of: circles, 31; hexagons, 34
Eccentric landscapes, 143, 144
Ecological design, levels of, 45, 46
Elements of design, basic, 12, 14
Ellipses: constructing, 158, 159; formal geometric, 40, 41, 157; freely drawn naturalistic, 56–60
Emphasis, 88–90
Enframement, 90, 91

Final landscape plans, of case studies, 99, 104, 111, 118, 123, 130
Flowing patterns, 53
Focal elements: with circular forms, 33; conceptual diagramming of, 7
Focalization, 90, 91
Form: as a basic element of design, 13; evolution diagrams, 98, 110, 117, 129; integration, 78–81
Fourty five degree themes, 18–20, 43
Fragmentation, 74–77
Fragrance: as inspiration, 5; as a nonvisual element of design, 14
Free-form. *See* Meander
Functional diagrams, 15. *See also* Concept, specific functional

Geometric form, 15–44; defined, 14; summary diagrams, 43–45
Golden mean rectangle: constructing a, 160; in spiral form development, 42
Graphic transformation, 16
Grid patterns: concentric circles and radii, 32, 155; distorted, 26; fourty five degree/ ninety degree, 150, thirty degree/ sixty degree, 151
Graded change, 78, 79

Harmony: with nature, 45; as a principle of design, 84–87
Hexagons: concentric, 152; constructing, 21, 153; manipulation of, 22–25
Hierarchy of space, 93, 94

Illusions, spatial, 26, 145–48
Imitations of nature, 46
Incongruity, 84–86
Informality, 54
Integration of form, 78–81

Interest, 87. *See also* Diversity
Irregular line. *See* Irregular polygon
Irregular organic patterns, 71
Irregular polygons, 65–67

Koru, 62

Line: as a basic design element, 12; irregular, 65; meandering, 56; organic, 72

Meander, the, 48–56. *See also* Case studies
Mood, in concept development, 4
Movement: as a basic design element, 13; corridors of, 6
Multiple forms, manipulation of, 78–81
Mystery, sense of, 94

Naturalistic form, 45–77; defined, 14, 47
Ninety degree: connections, 27, 33, 59, 78–81; grid patterns, 15, 150. *See also* Rectangular themes
Nonvisual elements of design, 13, 14

Obtuse angles: as form connectors, 78, 79; in irregular polygons, 65
Organic edge, the, 70–74
Oval forms. *See* Ellipses
Overlapping counter forms, 138

Pentagons, constructing, 154
Physical form, from idea association, 4
Place, sense of, 1
Plane: as a basic design element, 12; intersections with cones and cylenders, 41
Point, 12
Political landscapes, 142, 143
Polygons. *See* Irregular polygons
Primary geometric shapes, 15
Principles of design, 82–94; in case studies, 100, 105, 112, 119, 124, 131
Principles of organization, 82–94
Program: development, 8, 45; objectives for case studies, 100, 105, 112, 119, 124, 131
Progression of space, 94
Project, case study: one, 96–102; two, 103–107; three, 108–14; four, 115–21; five, 122–26; six, 127–33
Proportion. *See* Scale

Quarter circle segments, 156. *See also* Circle segments

Random expression: in irregular polygons, 65; in the organic edge, 70, 72, 75
Rectangular theme, 15–17, 43
Reflex angles, in irregular polygons, 66
Relationships, diagramatic, 5
Repetition, 92
Rhythm, 51, 91

Scale, 93
Scallops, freely drawn, 56–60
Schematic drawings. *See* Concept plans
Sense of: mystery, 49; place, 1
Simplification, 22, 28, 33, 39, 88
Social landscapes, 142, 143
Sound: as a focal element, 89; as inspiration for design, 5; as a nonvisual design element, 13
Spatial qualities, 16, 100, 105, 112, 119, 124, 131. *See also* Three dimentional expression
Spiral: the free form, 61–64; the logarithmic, 42; placement of hexagons, 24
Spirit of site, 1
Structuring themes, of case studies, 100, 105, 112, 119, 124, 131
Symbolism in design, 2, 3
Symbols, abstract graphic, 7

Tangents. *See* Arcs and tangents
Tension, 86, 137, 138
Texture: as a basic design element, 13; contrasts for emphasis, 89
Theme composition diagrams, of case studies, 97, 103, 109, 116, 122, 128
Three dimentional expression: in angular form, 20, 23, 25, 67–69; in circular form, 29–31, 33, 34, 37, 39–41; in meandering form, 49, 52, 55; in organic form, 73–76; in rectangular form, 16, 17, 18; of scale and sequence, 93, 94; in spiral form, 61, 64. *See also* Completed landscapes
Thirty degree/ sixty degree themes, 21–25, 43
Touch: as inspiration for design, 4; as a nonvisual design element, 14
Transitional forms, 78–81

Uniqueness, 90
Unity: with circular themes, 27; with organic themes, 75; as a principle of design, 82–84, 87
Use areas, 6

Wavelike patterns: from meandering form, 50, 53; from spiral form, 62